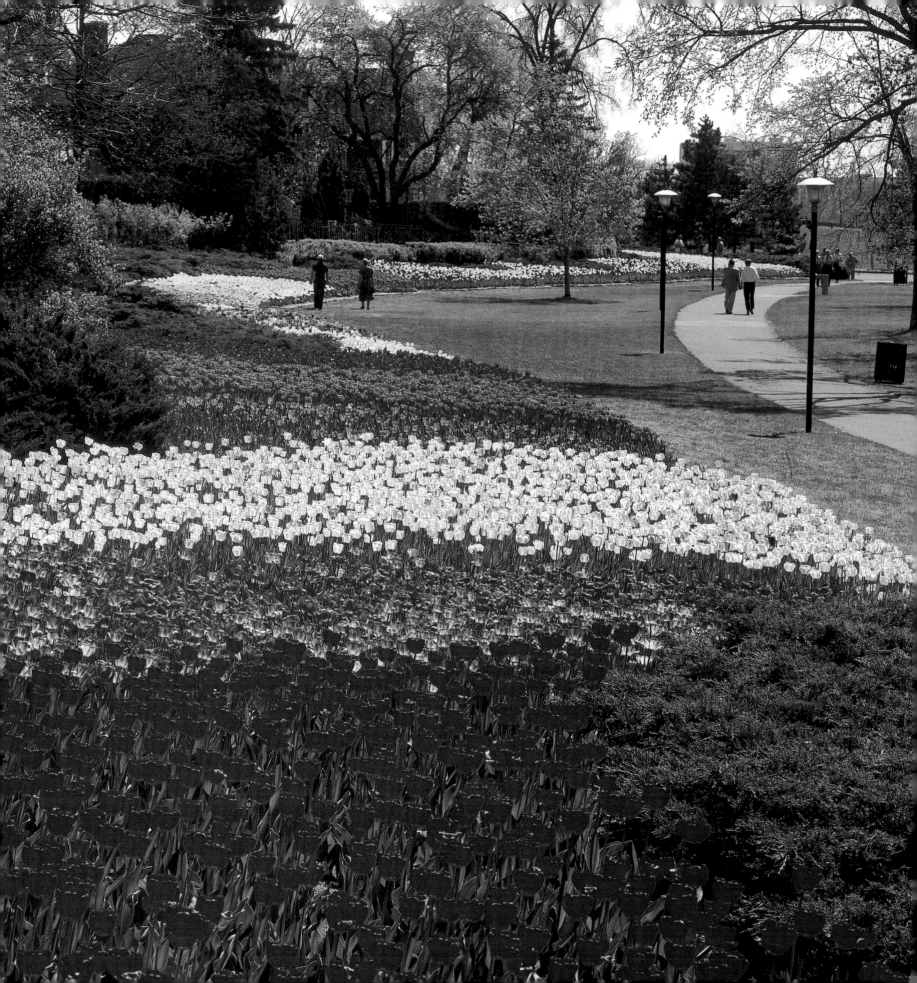

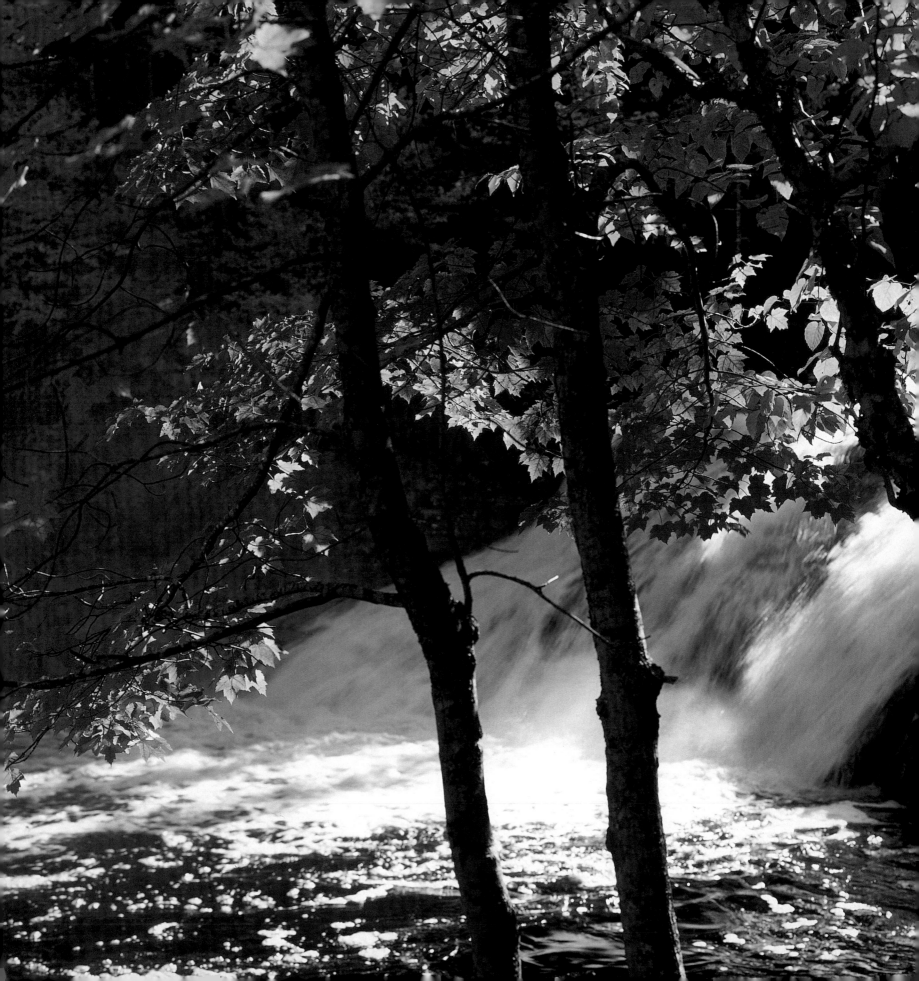

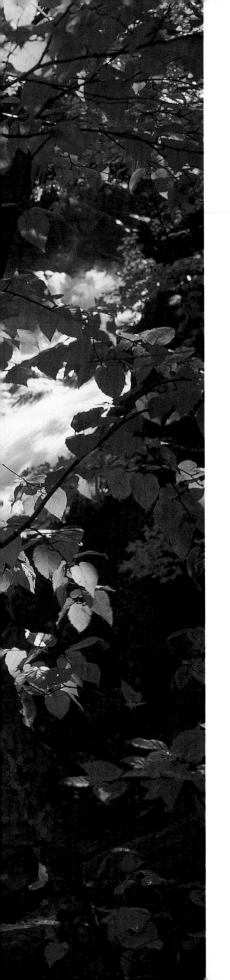

Malak's
Canada

KEY PORTER BOOKS

PAGE 1 *Canadian tulip Festival, Dow's Lake, Ottawa. Malak Karsh made an indelible contribution to Ottawa and Canada as a photographer and as the originator of the Canadian Tulip Fesitval. His idea has grown into the largest tulip festival in the world and one of Canada's oldest and most successful community celebrations. In 2002, the festival honoured its founder by dedicating its 50th anniversary celbrations to his memory.*

PAGE 2 *Mary Ann Falls, Cabot Trail, Nova Scotia. The trail named after navigator and explorer John Cabot, is 158-mile loop road on orthern Cape Breton Island, Nova Scotia, that overlooks rolling hills, deep valleys, waterfalls, and picturesque and rugged Atlantic.*

National Library of Canada Cataloguing in Publication

Malak

Malak's Canada / with a introduction by Knowlton Nash.

ISBN 1-55263-494-9

1. Canada—Pictorial works. 2. Photography, Artistic. I. Title.

FC59.M34 2002 779'.9971064'092 C2002-904077-9
F1017.M34 2002

The publisher gratefully acknowledges the support of the Canada Council for the Arts and the Ontario Arts Council for its publishing program.

We acknowledge the financial support of the Government of Canada through the Book Publishing Industry Development Program (BPIDP) for our publishing activities.

Key Porter Books Limited
70 The Esplanade
Toronto, Ontario
Canada M5E 1R2

www.keyporter.com

COVER DESIGN: PETER MAHER

KEY PORTER BOOKS

Printed and bound in Canada

02 03 04 05 06 07 6 5 4 3 2 1

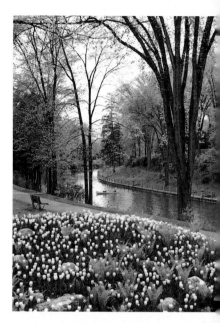

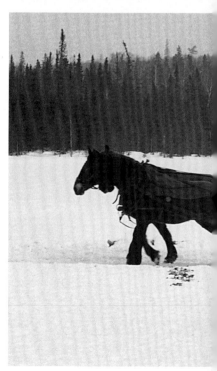

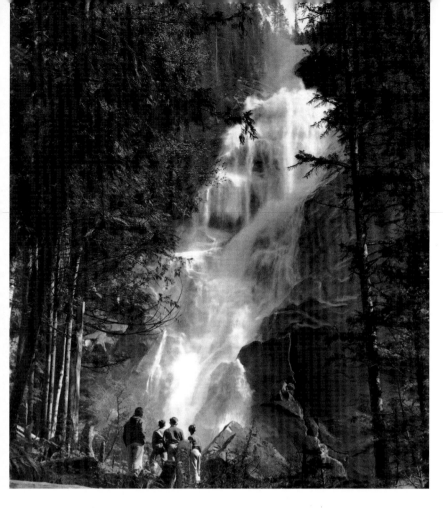

Shannon Falls, British Columbia. In the western region of British Columbia lies a beautiful waterfall rushing with glacier melt. At 1,099 feet, Shannon Creek slides down the glacially carved walls of upper Howe Sound, then crashes into piles of huge boulders.

OPPOSITE: *A gift from a Queen, Ottawa, Ontario. In 1945, Princess (later to become Queen) Juliana of Holland thanked Canada with a gift of 100,000 tulip bulbs for the role Canadian soldiers took in liberating Holland and for the hospitality extended to the royal family during their stay in Ottawa during the Second World War. This lovely tulip bed interspersed with ferns was planted along Colonel By Drive and the Rideau Canal in Ottawa in 1948.*

Horse-drawn logs, Gatineau, Québec. Taken in 1949, this photograph shows only a small part of the 605,000 cords of pulpwood brought out of the Gatineau bush that season. Horses pulled enormous loads of logs out of forested terrain where trucks could not travel. These sleighs, brought to the dump lake by trucks, are hauled out on ice by horses to be placed more advantageously for the spring log drive.

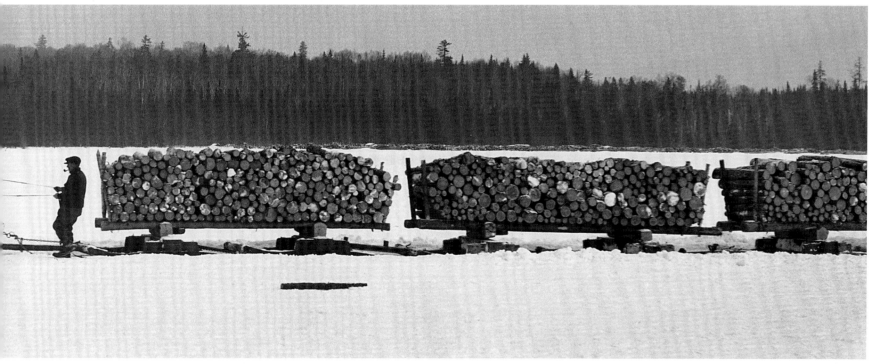

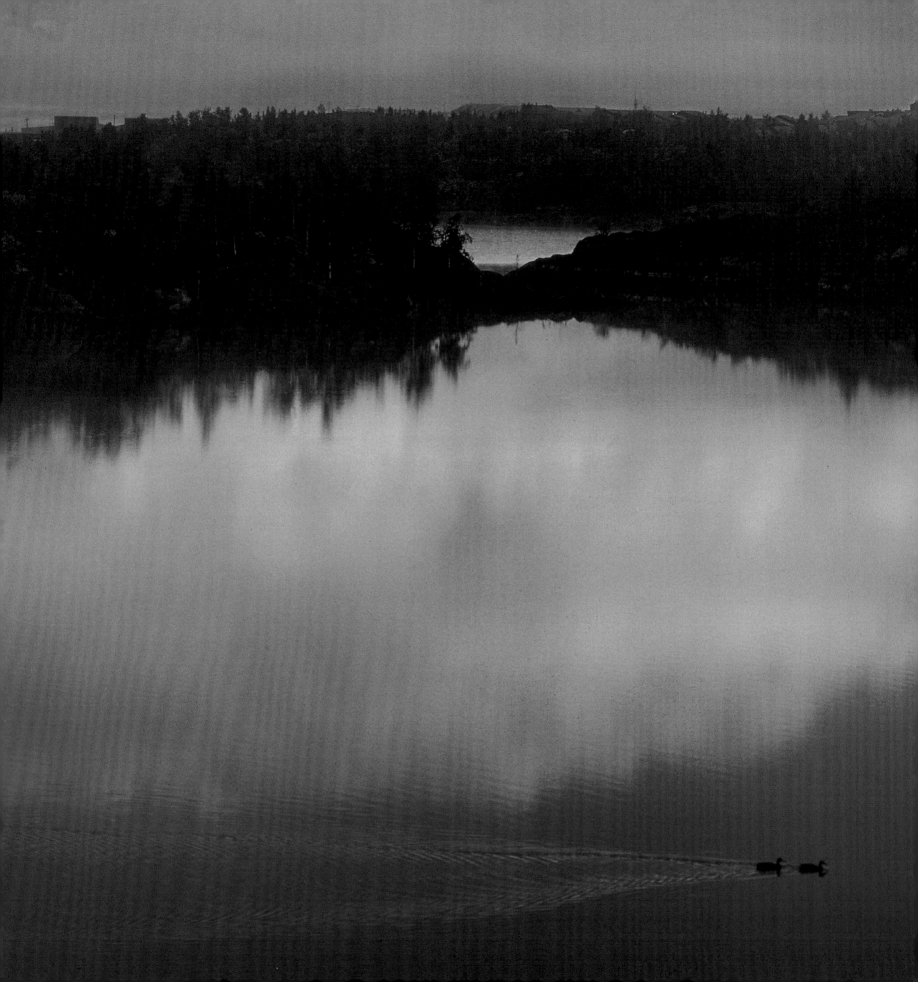

Contents

OPPOSITE *Great Slave Lake, Northwest Territories. The fifth-largest lake in the North American continent, discovered in 1771 by Samuel Hearne and named after the Indian slaves who formerly lived on its shores.*

Preface

In September 1939 when Canada declared war on Germany, my father Lt. Col. A.W. Holmes, a pharmacist, was summoned to Ottawa to open the Canadian Medical Stores. He had been in charge of the Canadian Medical stores in London, England, during the First World War and still had the key to the Ottawa building that he had closed up in 1919. We followed him to Ottawa soon after. In 1941 I graduated from business college and started looking for work. I saw an interesting ad in the *Ottawa Citizen* for an "artistic secretary needed for photographic studio." Since I had always been good at art, I applied for the job and on April 1, 1941, I entered the wonderful world of the Karshes. Little did I dream that day, that it would be forever.

During this period Malak had been photographing Canada at War, both in Ottawa and on the East Coast and Newfoundland. His photographs appeared in national periodicals as well as in British and American publications. Major security and censorship regulations applied. He was not allowed to show any land or shoreline, and badges and insignia had to be retouched. All film had to be developed at night, rushed to Ottawa the next day, proofed and returned to the Eastern Air Command in Halifax, and then returned to Ottawa for final censorship. Meanwhile the papers would be calling me, frantic to get pictures, which were finally published three months later.

Malak and I were married on December 26, 1942, and thus began a sixty-year partnership full of rewards and hardships made easier because we were together. The hardships began early when Malak was diagnosed in February 1943 with tuberculosis and went into the sanatorium for four years. I closed the studio, sold his cameras, and bought Canada savings bonds with our total assets of $200. I got a job in a lawyer's office and rented a "room with breakfast" as close to the sanatorium as I could find. By 1946 Malak's indomitable spirit had carried him through and he was back behind his camera again. Recovered in full, he was now imbued with new purpose and had decided to change the direction of his photographic approach. Basing his new approach on the saying that "a picture is worth a thousand words," he had decided to produce editorial-type photos that would go beyond the pictorial and embody his thoughts and feelings.

Unfortunately in 1952 he contracted tuberculosis again and went back into the sanatorium. I had to let the photographic staff go. Our darkroom printer, Ignas Gabalis, whom Malak had brought to Canada from Estonia, found work with Malak's brother Yousuf, and continued to

work for him until Yousuf closed his studio in 1992. My mother came to Ottawa to look after our children, then aged 6 and 3 years, and 2 months old. I was able to keep up the mortgage payments on our home by taking portraits of children and filling orders from our extensive library of photographs. By 1954 Malak was in remission, for good this time, and once again working at full speed. He was to suffer other health drawbacks during his lifetime but always seemed to find the strength to work around them.

Malak was blessed with the limitless energy required for anyone with his deep passion to go beyond normal work limits. His day began before sunrise and he had no regard for tempest or temperature. When he traveled (and he traveled a lot) in search of that perfect photograph to convey his feelings for his beloved Canada, he often went eighteen to twenty hours at a time, much to the dismay of his bleary-eyed and exhausted assistants. They have told me how he changed their lives by inspiring them not to give up but to persist in following their dreams. His own chosen task of capturing the beauty of Canada humbled him. Once in a talk he gave to thank the YMCA for sheltering him when he first came to Canada in 1937, he said, "Canada is too vast for any one person to do it photographic justice in a lifetime." I feel privileged that I have been able to help him follow his dream and produce the images contained in this book.

In November 2001 when Malak died, our son Sidney was quoted, in a front-page headline in the *Ottawa Citizen,* saying that his father was a "Wonderful, Wonderful Man." He was indeed, a kind, loving, charming and gentle man who touched many people, while forever remaining thankful for the opportunity to be a Canadian. He was modest of his talents, keen to listen to the views and perspectives of others, generous with his personal time, and always an artist in the pursuit of his craft. He has been honoured in many ways, receiving the Order of Canada and the Keys to the City of Ottawa, and even having a street named after him.

Even though his work took him away from us for months at a time, he was a devoted family man. When our daughter Marianne was born in 1961 he was heard to say, "now I feel like a father." One of his greatest pleasures was watching his grandchildren grow up. To him they were part of his dream. I think he would have wanted to dedicate this book to them.

BARBARA KARSH, 2002

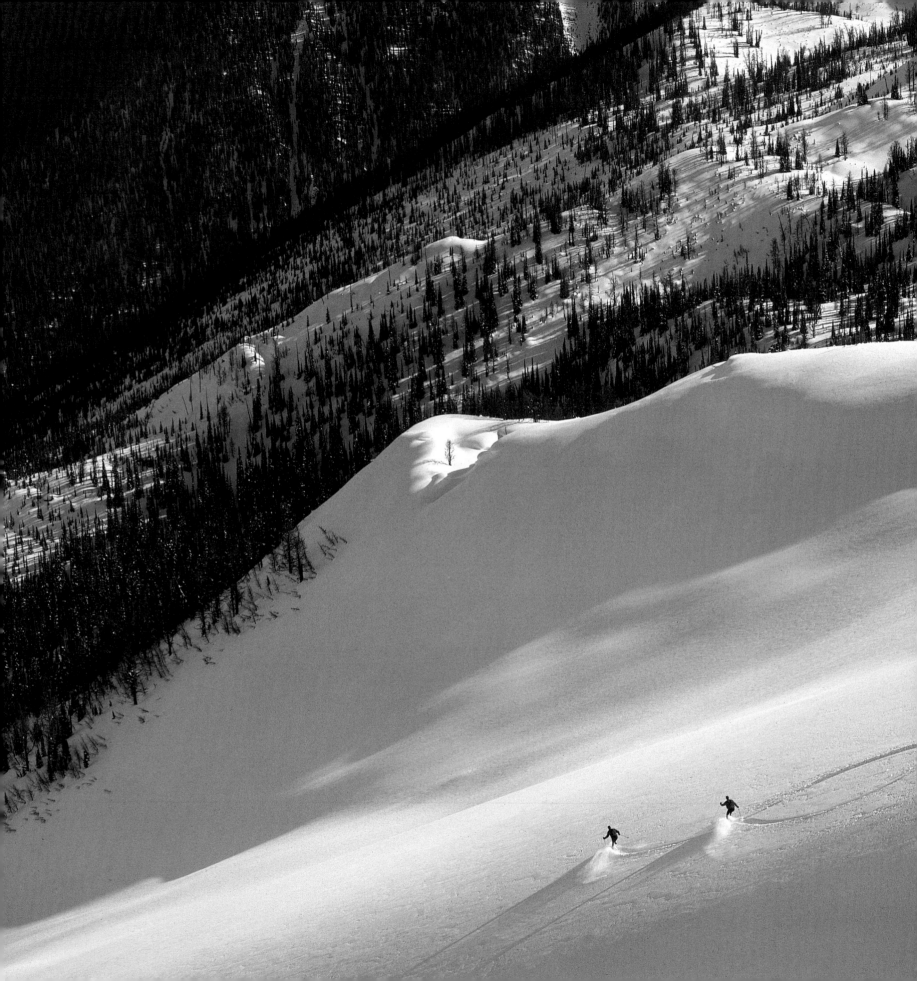

Introduction

"I live and breathe Canadian," Malak Karsh once said.

With his evocative photographs of what he called "my adopted and beloved Canada", he gave us a national family album and let us all "live and breathe" this land and its people.

Malak, his professional name to distinguish himself from his brother, the celebrated portrait photographer Yousuf Karsh, spent 60 years capturing the soul of Canada in more than a million and a quarter photos. He did it in a wide-ranging photographic exploration of the geographic, industrial and social landscape of the country and this book is a celebration of that exploration.

An Armenian born in Turkey in 1915, Malak came to Canada in 1937, worked alongside his brother for a few years and then struck out on his own joyous journey of discovery of Canada. The result has been a memorable and at times almost spiritual reflection of the grandeur of the Rockies, the waves thundering on the shore at Peggy's Cove, the neo-gothic drama of the Parliament Buildings, the lonely beauty of the Prairies and the icy tranquility of the North. But it's much more than that. His photos not only revealed the majesty of our geography, but also the character of our people and how the land has shaped our identity. Perhaps because we have had to adapt to a relentless, towering landscape, we look more to compromise than confrontation, are more patient than impulsive.

By train, plane and car, I must have travelled across this country a couple of hundred and more times over the years,

OPPOSITE *Skiing in the Bugaboos, British Columbia. The Bugaboos, located northwest of Invermere in the Purcell Mountains, are a popular skiing area today. In 1893, "the Bugaboos" were noted on a map by Gold Commissioner A.P. Cummins, and in 1906 Chief Geographer James White was told their usual name referred to the "loneliness of the place."*

and I never cease to be awed and inspired by the sheer, rugged beauty of our geography and the rich variety of our social landscape: staring into the misty Atlantic from a Newfoundland outport, standing on the red soil of Prince Edward Island, eating lobsters in Shediac, N.B, striding through the swirling crowds on the multi-ethnic streets of downtown Montreal, Toronto or Vancouver, or driving past the wheat fields on the endless, flat Prairies. You simply can't help falling in love with the place, and leafing through Malak's photos is a glorious revisit with stored memories.

It's not in our national character to loudly boast about our country, but his pictures so it for us. Actually, the "picture" is far too shallow a word to use in describing how his shimmering images provide a national sense of self. He sought to do with a camera what the Group of Seven did with paint brushes.

But not only did Malak reflect the spell-binding geography and people of Canada, he also put a face on industrial Canada with his photographic reflection of industries such as aluminum, pulp and paper and textiles. He dramatically illustrated the interconnection of paper and politics with a photo of logs floating down the Ottawa River past the Parliament Buildings, enroute to the pulp mill. That photo adorned the back of our one dollar bill from 1974 to 1987 when it was replaced by the loonie. In many ways, Malak was our version of Ansel Adams or Margaret Bourke-White who photographically captured the scenic and industrial heart of the United States.

Malak's remarkable range of interests is exemplified by his passion for tulips, begun in 1946 when he first photographed the Parliament Hill tulips given to Canada by Princess (later Queen) Juliana of the Netherlands as thanks for sheltering her family during World War II. Malak became the world's best known tulip photographer through the beauty of his sensuous close-ups of a single tulip and dramatic wide shots of thousands of the long stemmed tulips seemingly standing at attention in row after row like Royal regiments in pink, red, and yellow Busby hats. Through his photos, he became known as "The Tulip King."

Wherever he pointed his camera, Malak breathed life and drama into his pictures, producing a photographic love story of Canada. When he died in November of 2001, he left a legacy of photography that enriches all of us.

The day he arrived in Canada in 1937, Malak went hiking with his brother Yousuf in the Gatineau Hills in Quebec just outside Ottawa and was overwhelmed by the October woods afire with red, orange and yellow leaves. He now lies buried in those same hills at Wakefield, Quebec.

KNOWLTON NASH

Trans-Canada Highway near the Radium Hot Springs, B.C. The hot springs feature temperatures up to 114°F, among the hottest in the Rocky Mountains.

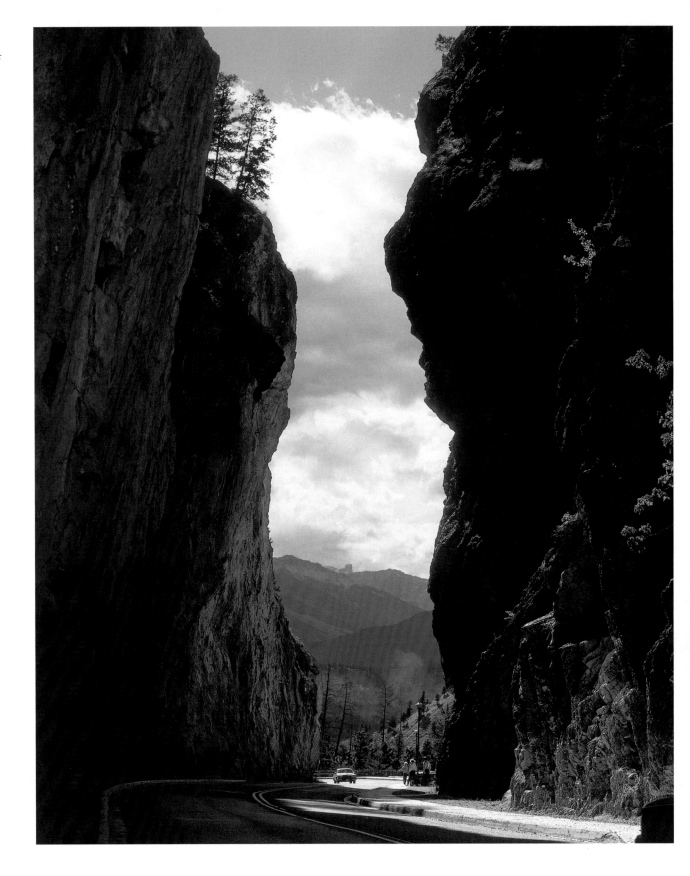

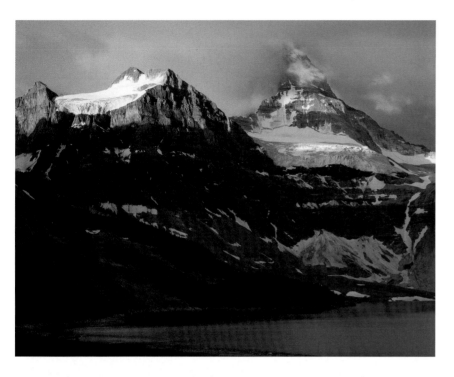

Mount Assiniboine, B.C. Located just south of Banff, Alberta, in a provincial park that bears its name and features vast areas of ruggedly beautiful Rocky Mountain scenery, this impressive formation was named after the prairie natives who hunted in the area.

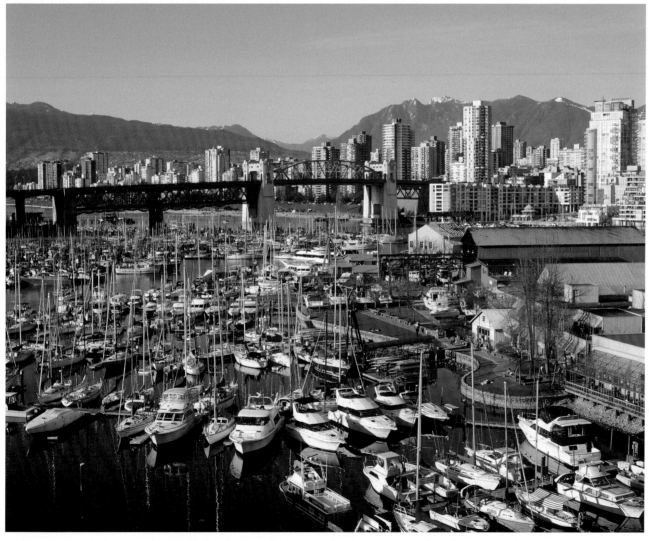

Granville Island and False Creek Marina, Vancouver. Named in 1870 after Lord Granville, Secretary of State for the Colonies, Granville Island was once a small village. Now it is an integral part of the city of Vancouver, B.C.

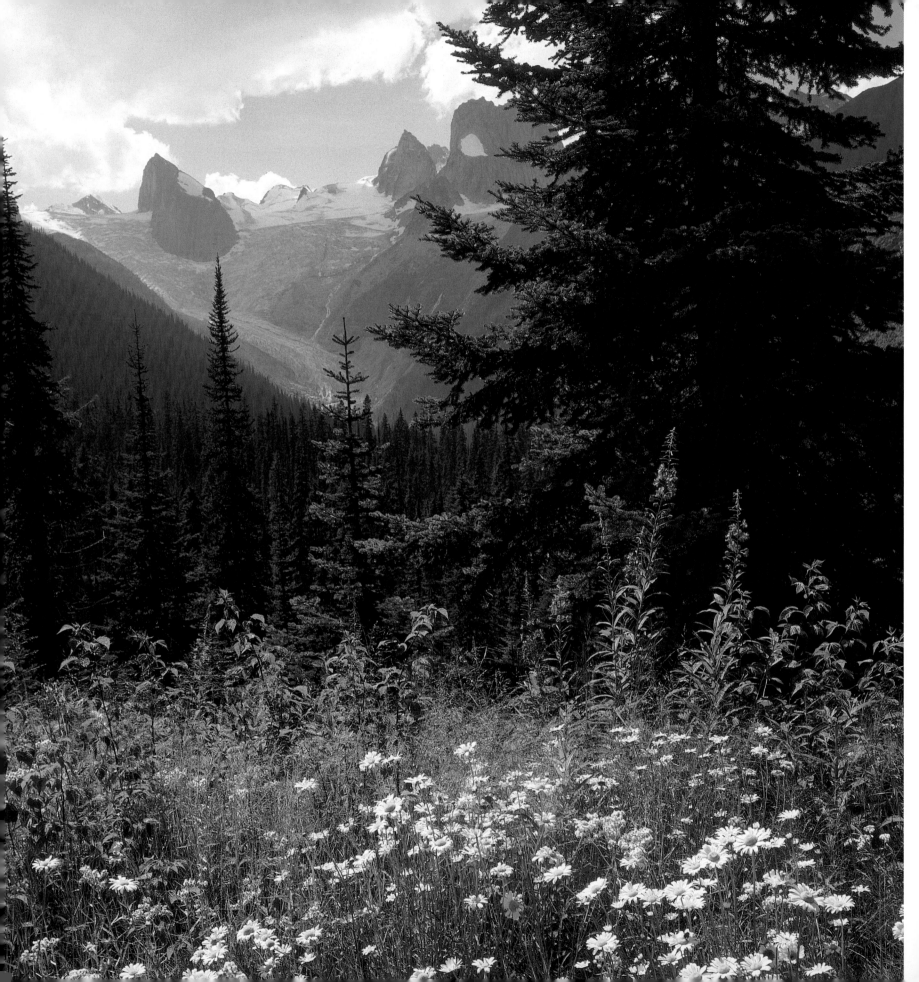

OPPOSITE *Bugaboo Mountains,*
B.C. The erosive forces of water and
glacial ice have removed much of the
weak overlying rock of these moun-
tains, revealing the solid granite
masses and chiselling them into the
well-known and spectacular spires of
the Bugaboo region.

Bugaboo Mountains, B.C. The
Bugaboo Mountains are a world-
renowned rock- climbing area, as
well as the birthplace of the North
American heli-skiing industry—
an excursion by helicopter to remote,
pristine skiing areas.

Mount Assiniboine Provincial Park,
B.C. Known for its spectacular hik-
ing trails, jagged peaks, shimmering
lakes, glistening glaciers and sun-
dappled alpine meadows, the park's
wilderness scenes are some of the most
stunning in the Canadian Rockies.

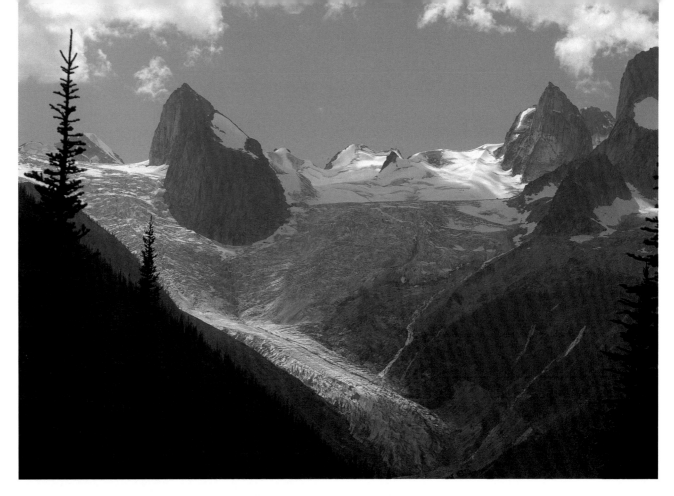

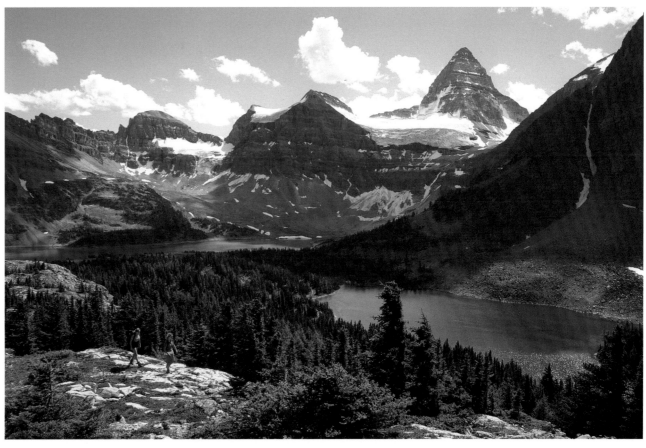

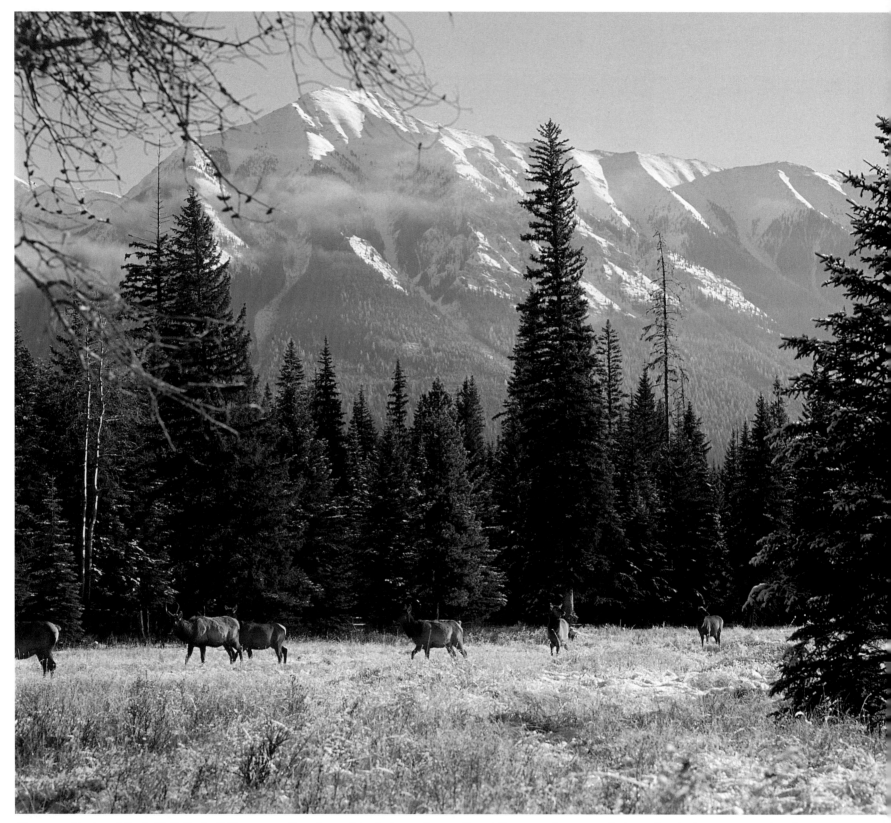

Kootenay National Park, B.C. In its 543 square miles, the park includes verdant valleys (elk on grazing grounds shown here), deep canyons, thundering waterfalls and mineral hot springs.

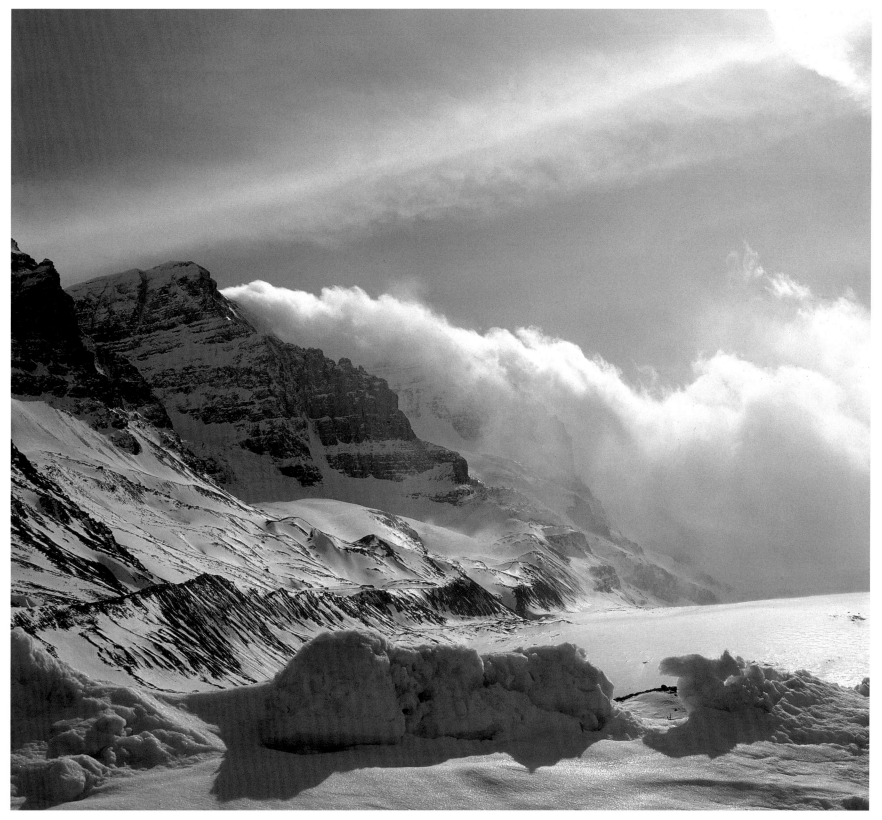

Winter storm, Mount Assiniboine Provincial Park, B.C. This massive park encompasses a rugged but picturesque landscape that epitomizes the beauty of the Rocky Mountains. With its lakes and meadows surrounded year-round by snow-capped peaks, Mount Assiniboine is a World Heritage Site.

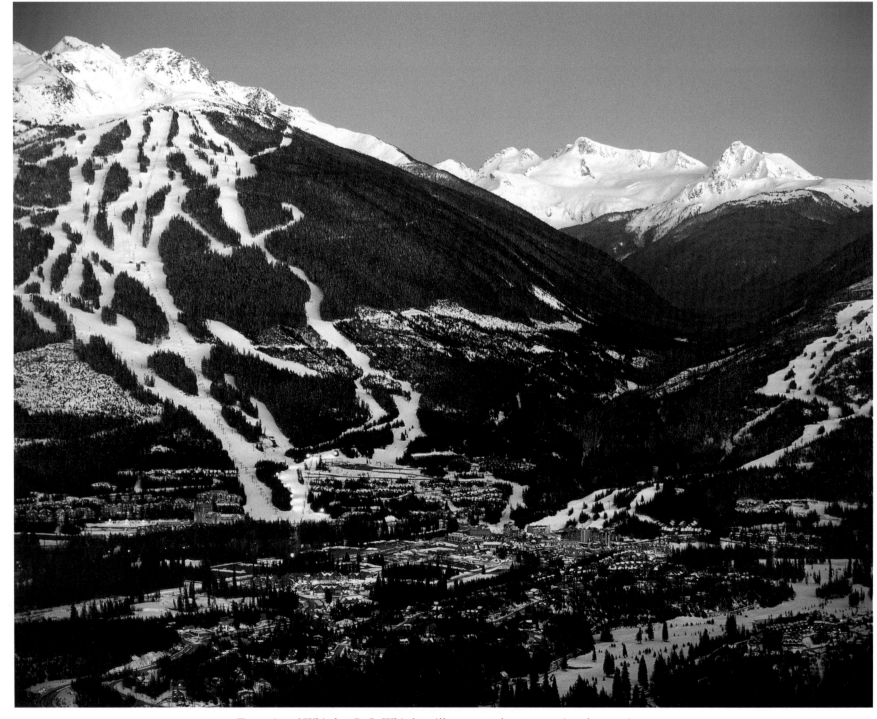

Town site of Whistler, B.C. Whistler village, a modern recreational town, is world-famous not only for its alpine skiing, but also for its superb summer facilities.

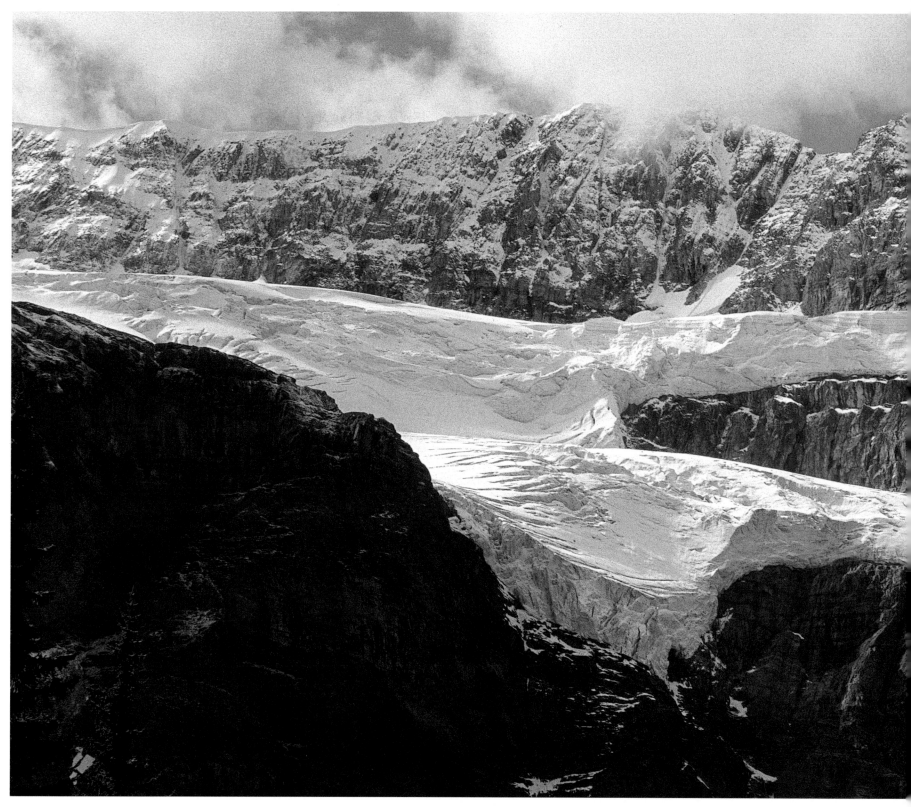

Glacier National Park, B.C. Heavy snowfalls, sometimes in excess of forty feet, have built up massive glaciers—3,000 metres high in this photograph—on the glistening peaks of the mountains.

OVERLEAF *Mount Robson Provincial Park, B.C. The half-million-acre park features the magnificent Mount Robson, one of the highest peaks in the Canadian Rockies, with a permanently snow-covered summit.*

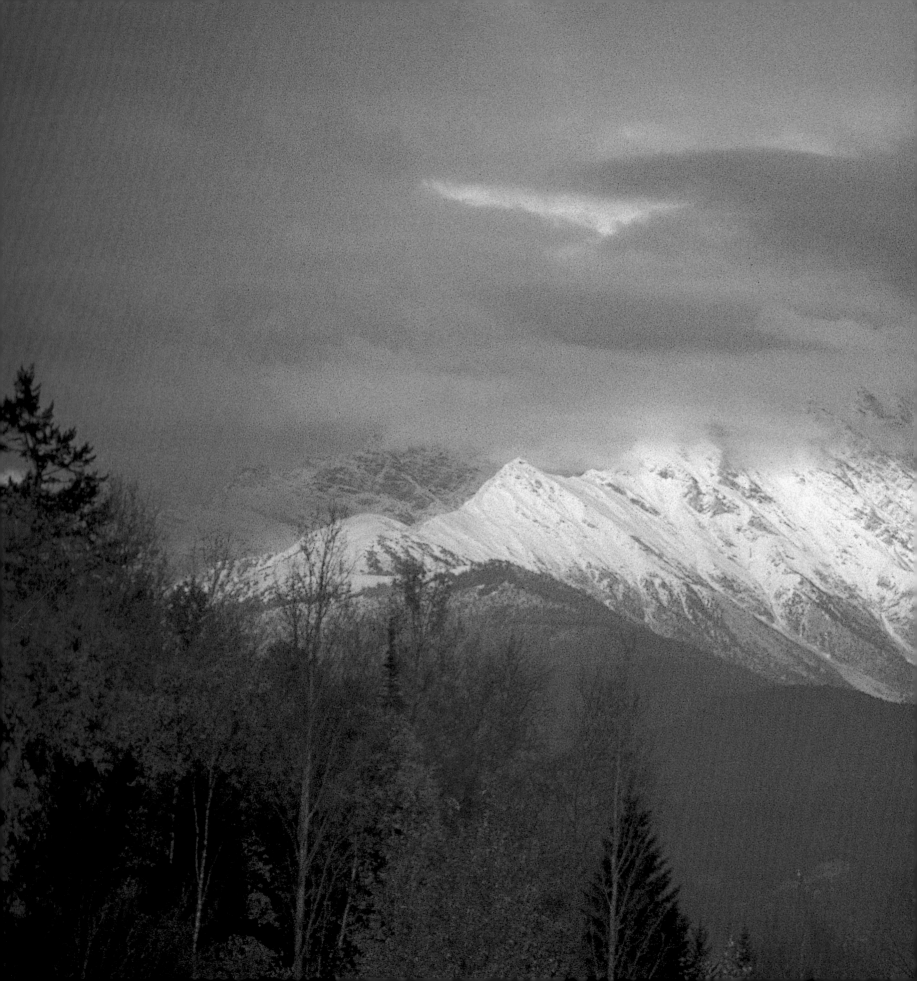

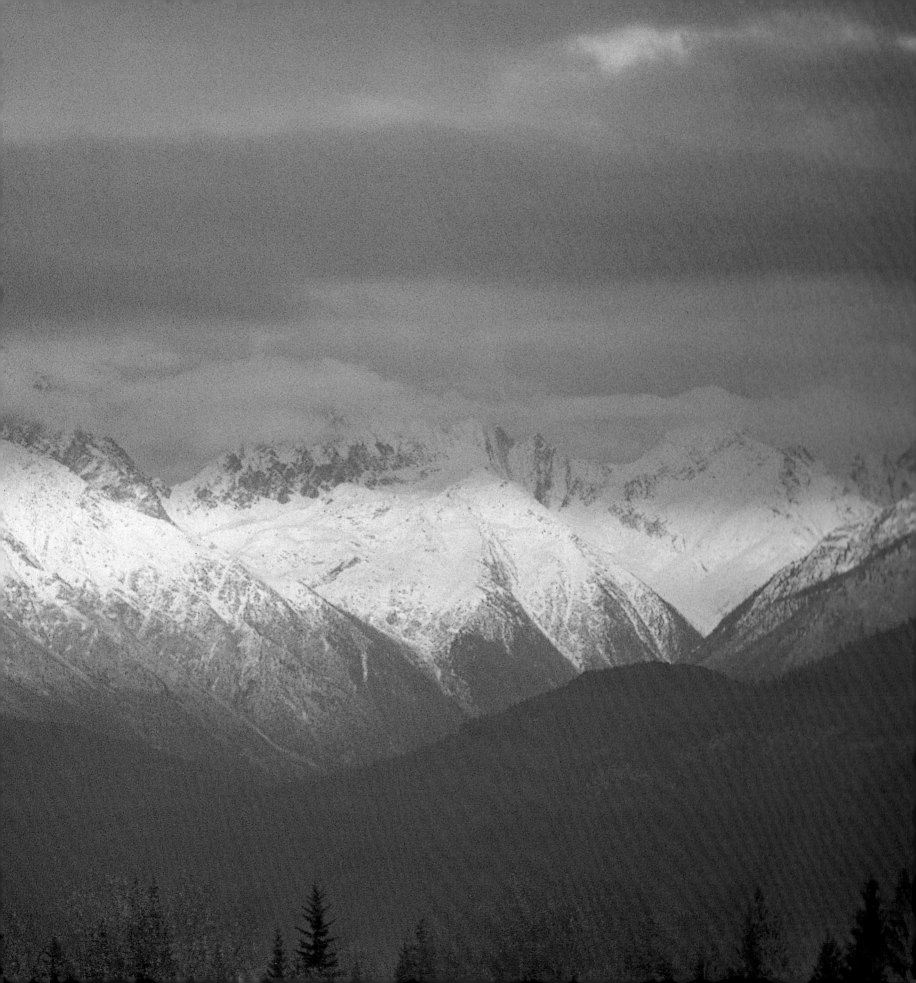

Kluane Lake, Kluane National Park, Yukon. The Southern Tutchone name from which the English word "Kluane" is derived means "big whitefish lake." This lake, the highest and largest in Yukon, is surrounded by mountains and full of icebergs.

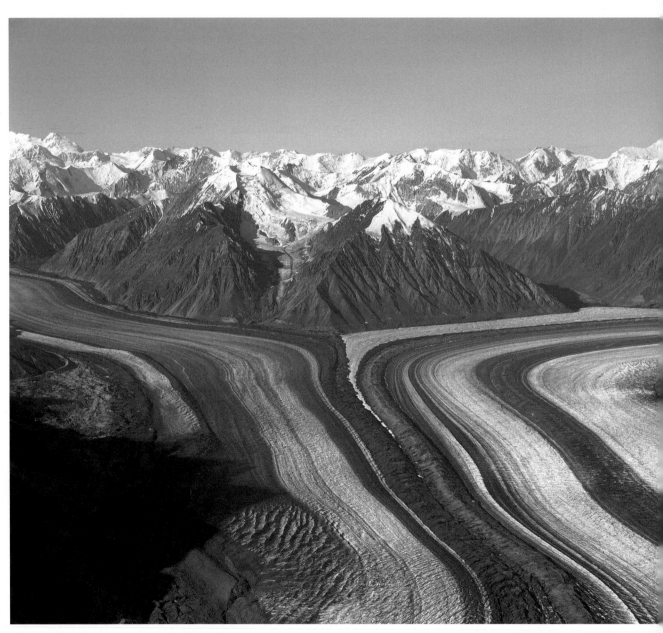

Kaskawulsh Glacier, Kluane National Park, Yukon. Kluane National Park, in southwestern Yukon, boasts massive glaciers and 100-foot icebergs, while Yukon's most well-known glacier, the Kaskawulsh, has a valley floor that is a shining river of ice.

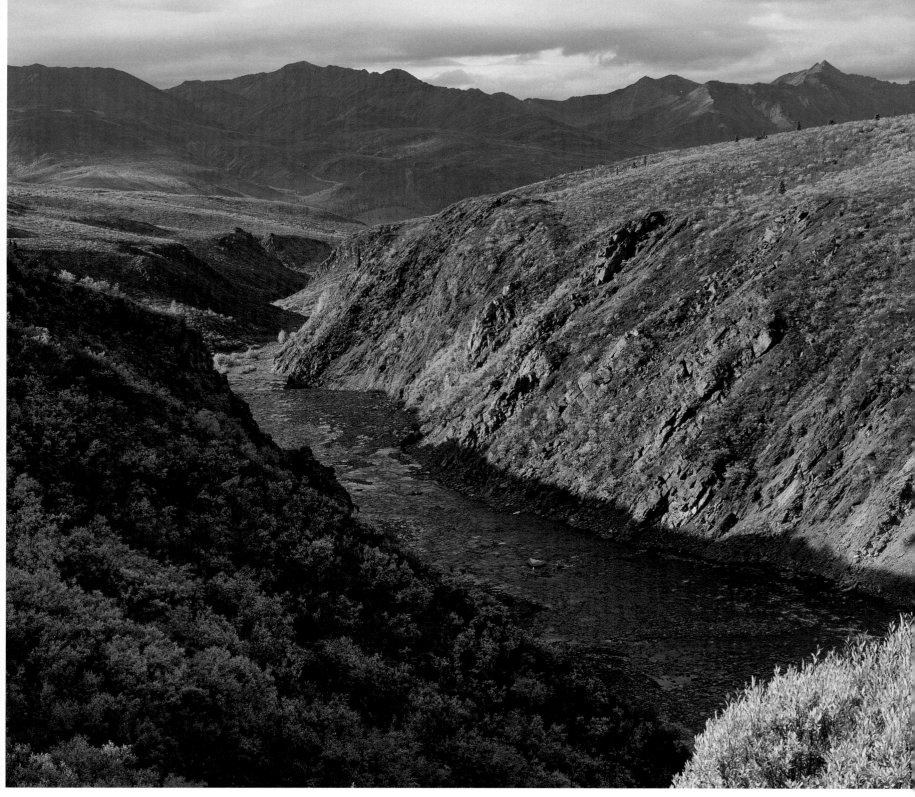

North of Tombstone Mountain, Tombstone Territorial Park, Yukon. This park was established to protect the life, landforms and heritage of the subarctic wilderness. The Dempster Highway runs through the park, providing access to spectacular views and tundra environments seen nowhere else in Canada. While Tombstone Mountain is the best-known landform, the park contains a variety of seldom seen permafrost landforms such as pingos, palsas and patterned ground.

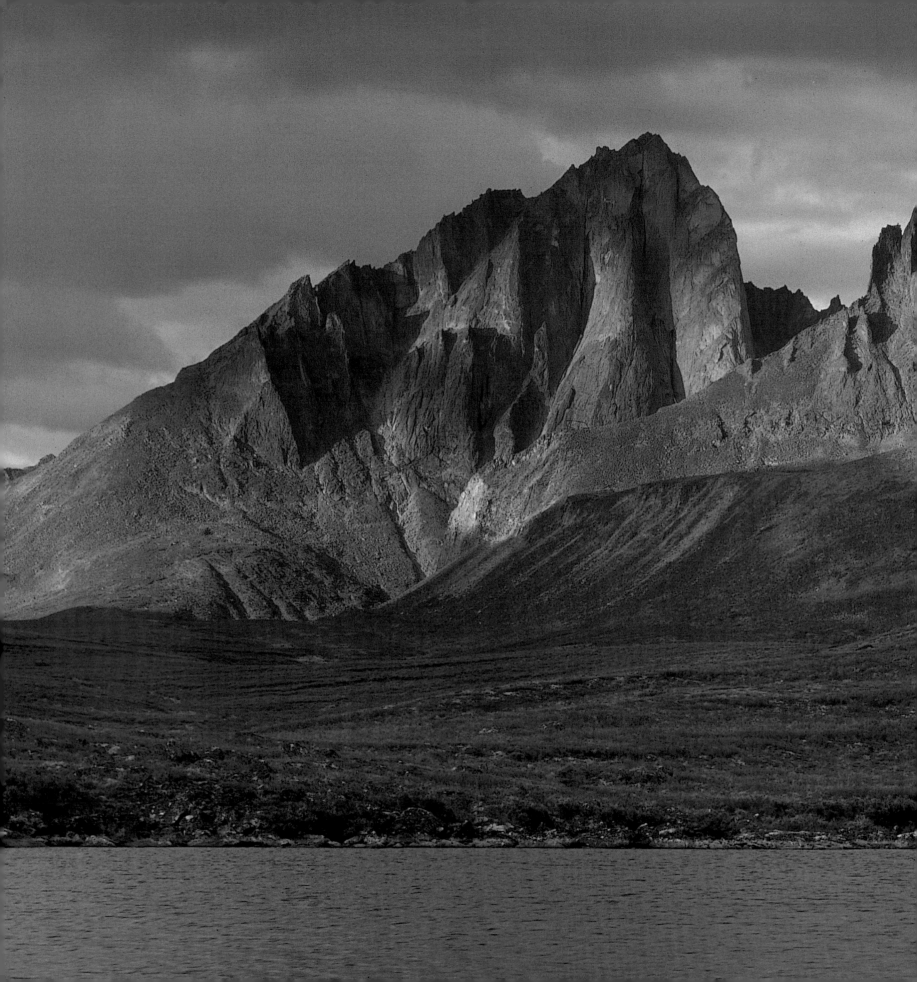

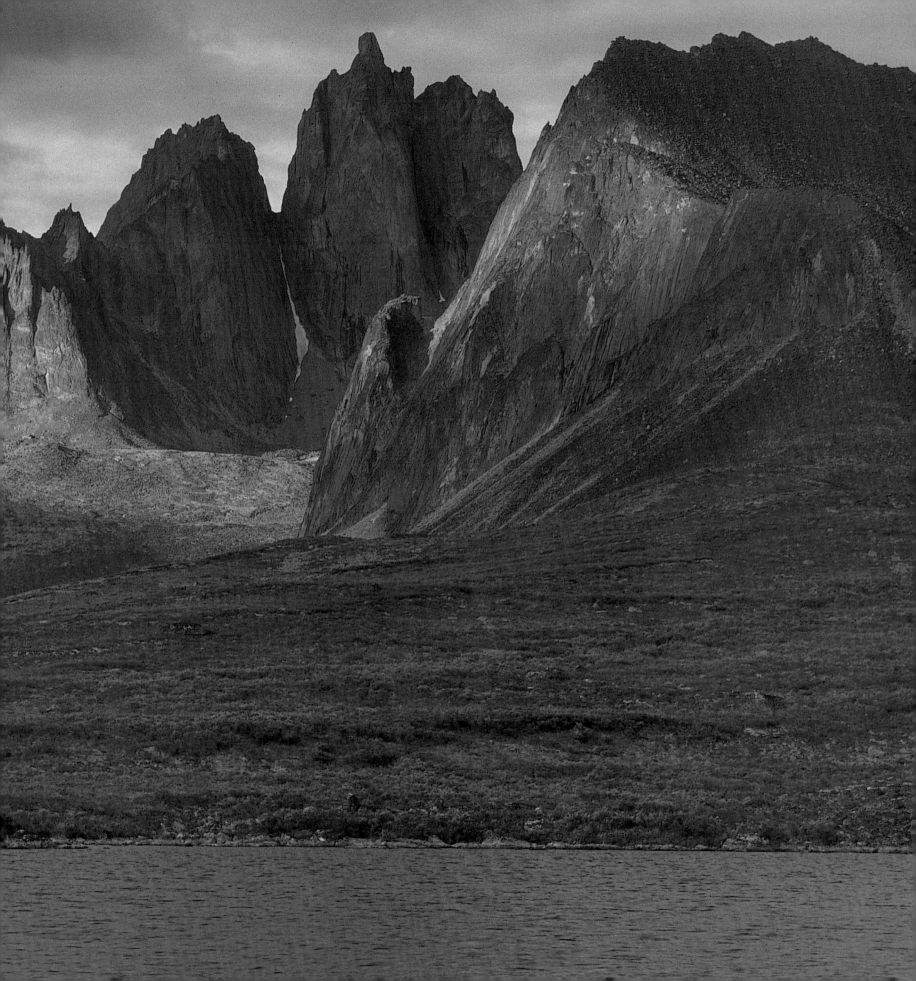

PREVIOUS PAGE *Tombstone Mountain, Tombstone Territorial Park, Yukon. Tombstone Mountain is 2,193 metres high, with a vertical rock wall that is nearly two kilometres from base to top. Over millennia, the black basalt rocks have weathered and split into spires and near-vertical walls. The aboriginal peoples called the Tombstone Range Odhah Ch'aa Tat ("among the sharp, ragged mountains").*

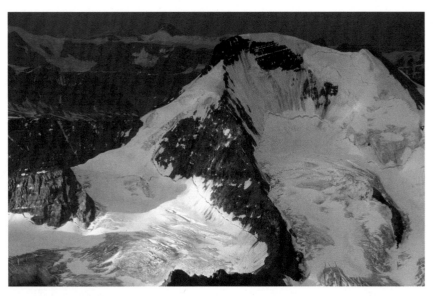

Mountains, Yukon

Dawson City, Yukon. The site of the world-famous Klondike Gold Rush of 1898 that followed the discovery of gold in Bonanza Creek on August 16, 1896. The rush made famous the "Poet of the Yukon," Robert W. Service, a young English bank clerk.

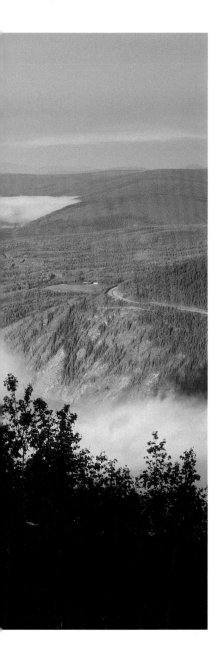

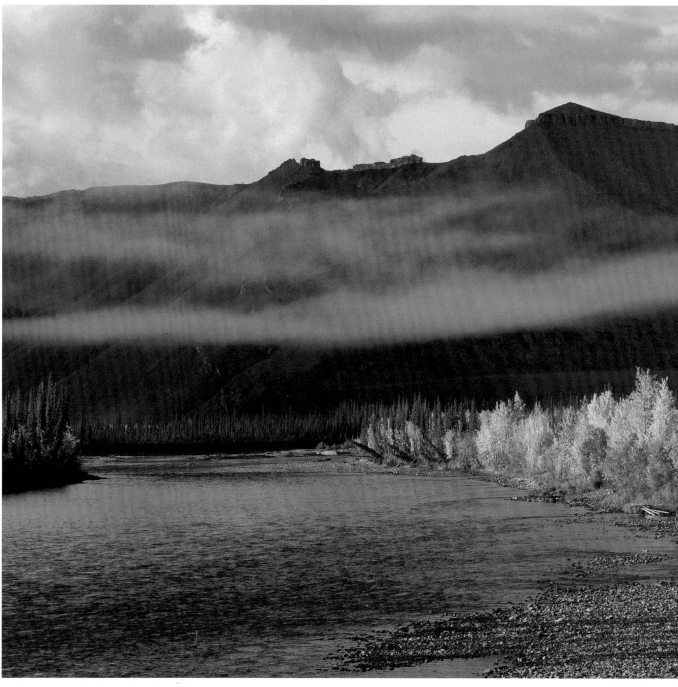

Ogilvie River, Yukon. Like the Ogilvie Mountains from whence it flows, the river was named after William Ogilvie, Commissioner of the Yukon Territory, who crossed the mountains in 1888.

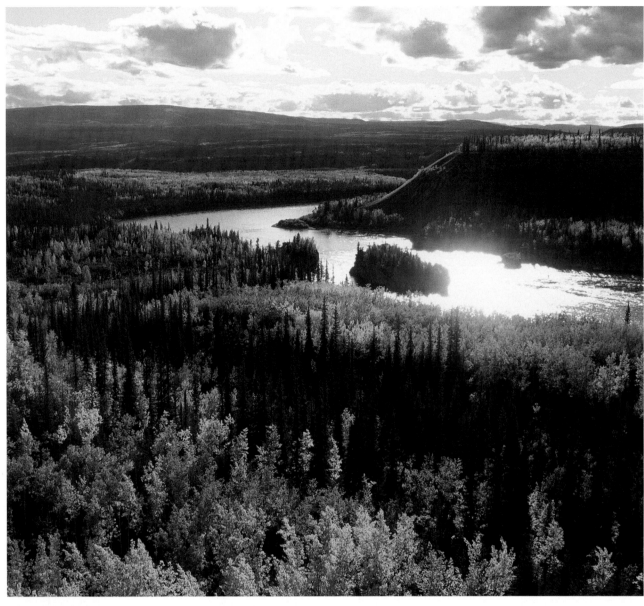

Mountains, Yukon.

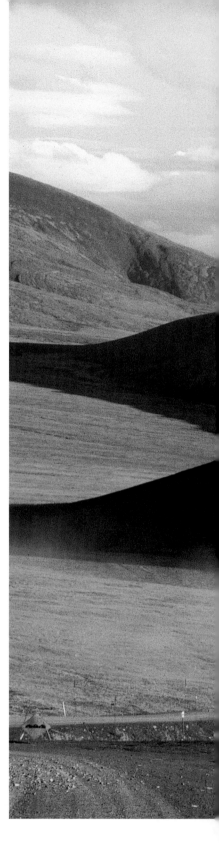

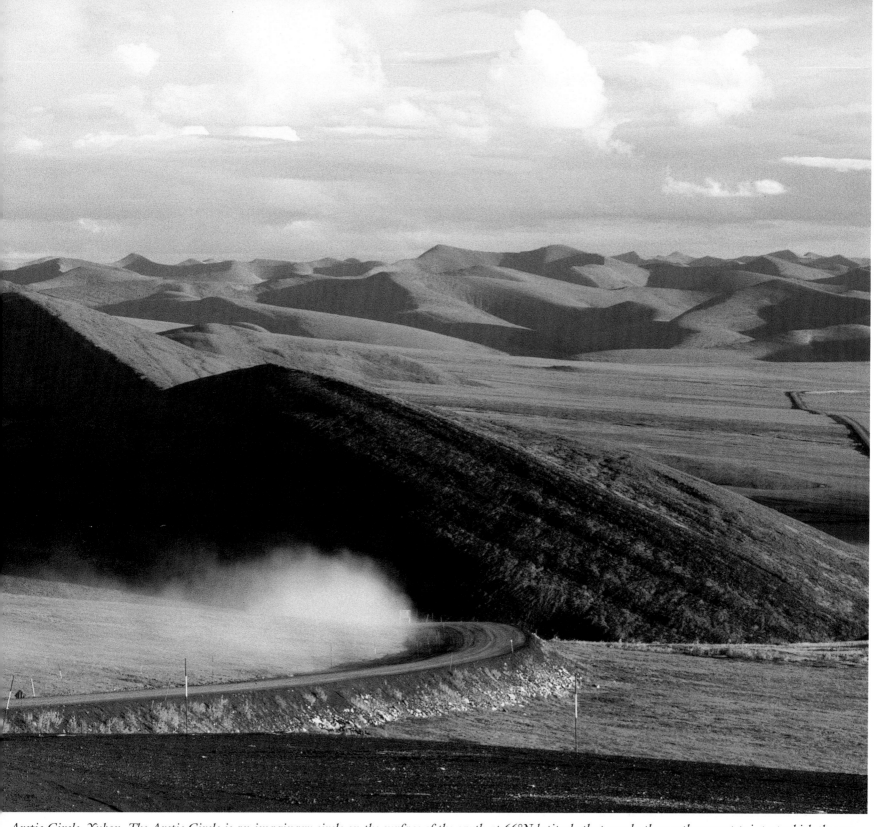

Arctic Circle, Yukon. The Arctic Circle is an imaginary circle on the surface of the earth at 66°N latitude that marks the northernmost point at which the sun can be seen at the winter solstice (about December 22) and the southernmost point of the northern polar regions at which the midnight sun is visible.

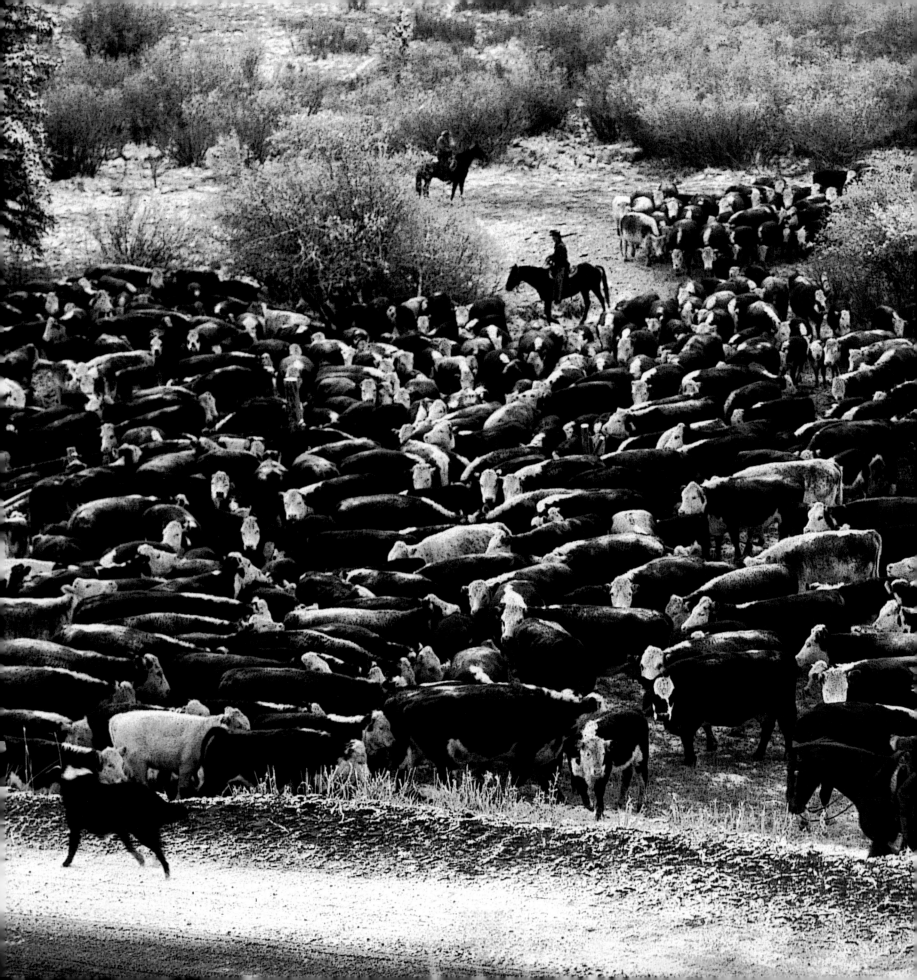

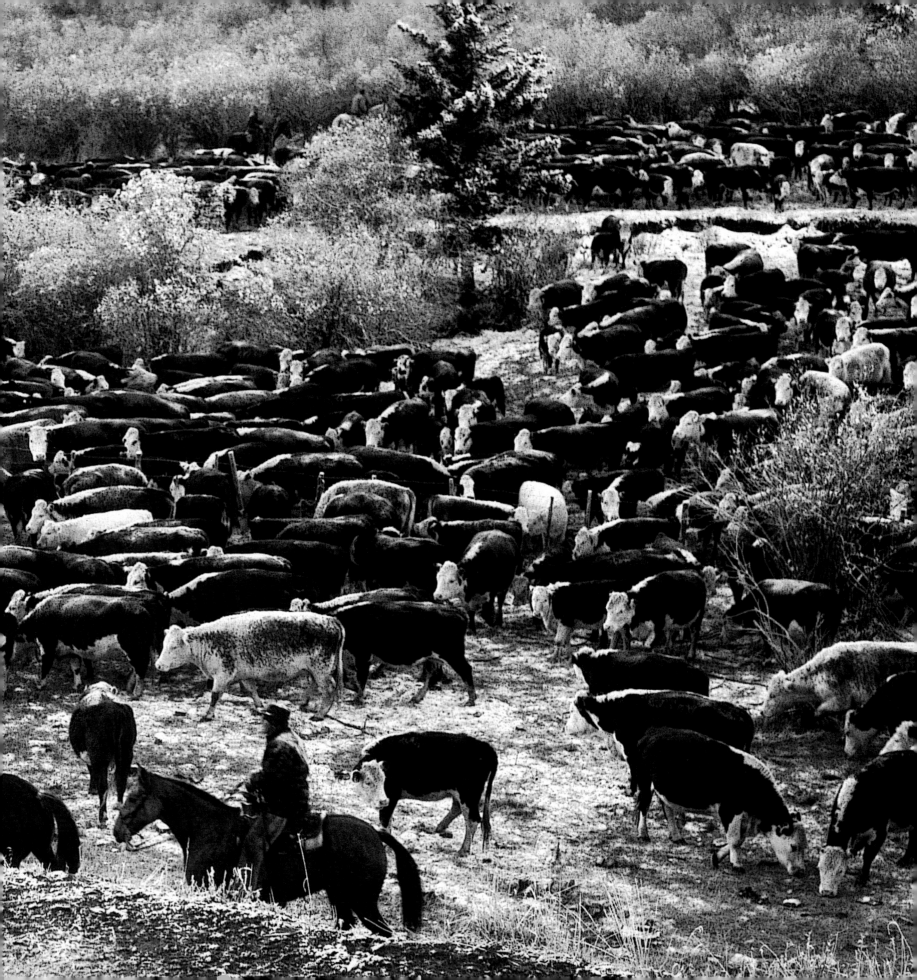

Cattle roundup in Turner Valley, Alberta. The season for the Alberta cattle roundup arrives without regard for the comfort of men, horses or cattle—or photographer Malak!

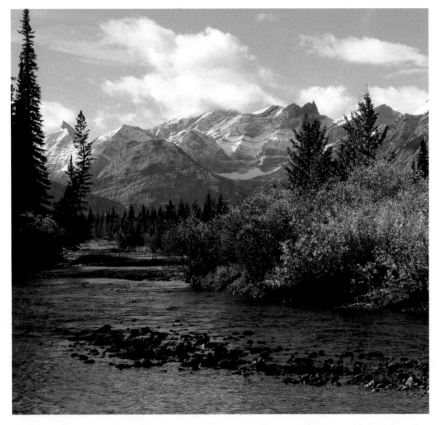

Ribbon Creek, Kananaskis Provincial Park, Alberta. This beautiful, isolated park became world-famous in the summer of 2002 as the location selected for the 2002 G8 meetings.

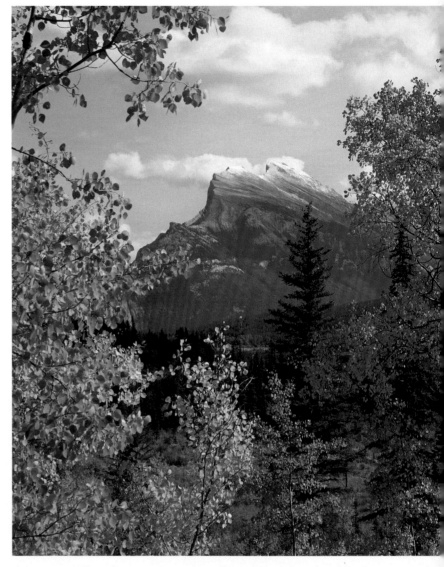

Mount Rundle, Alberta. Mount Rundle, in Banff National Park, was named after Robert Terrill Rundle, who served as the first Protestant missionary in Alberta. Indeed, at the time, there was no other missionary of any faith working so far west on the Alberta plains.

OPPOSITE *Columbia Ice Field, Alberta. Because of its proximity to the town of Banff, Alberta, and its easy accessibility, the largest body of ice below the Arctic Circle in North America is a popular tourist attraction for those who wish to walk on an ice field*

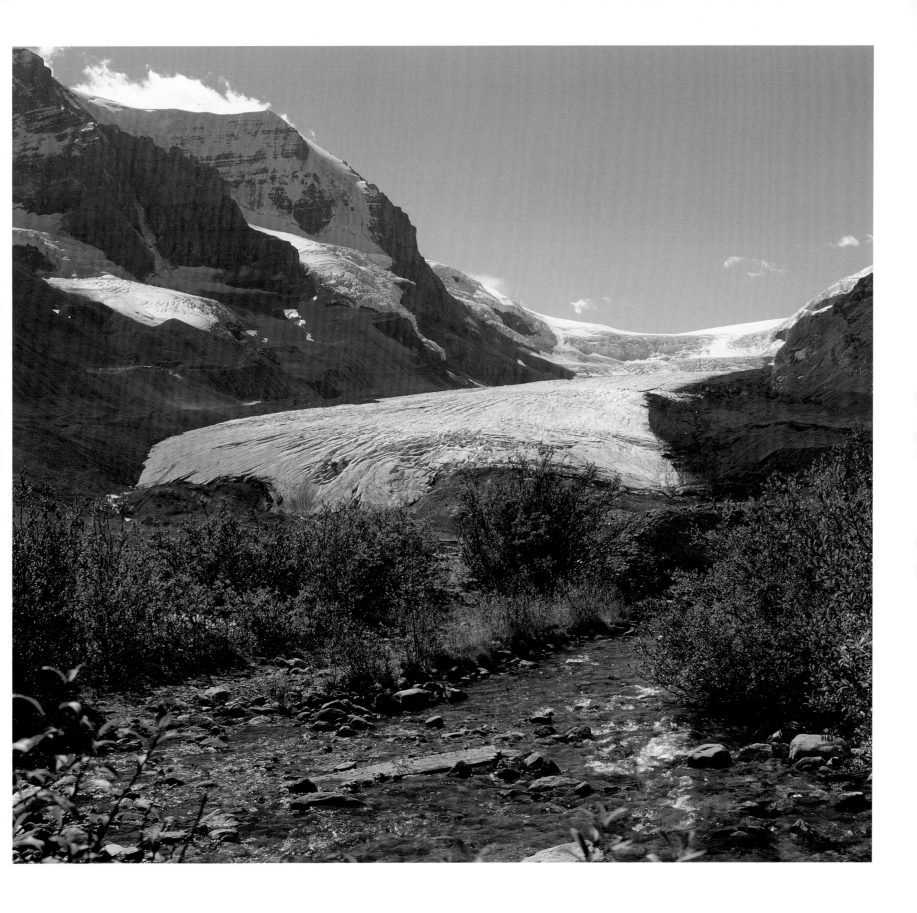

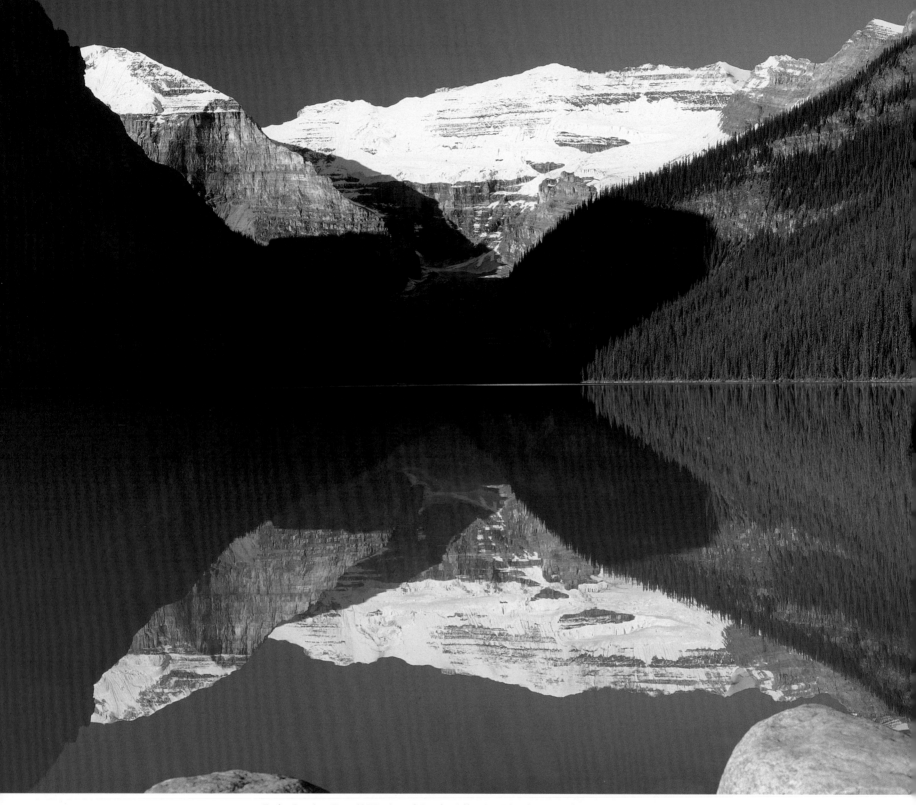

Lake Louise, Banff National Park, Alberta. This beautiful mountain lake was named by Canadian Pacific Railway surveyors in honour of Princess Louise, daughter of Queen Victoria and wife of the Marquess of Lorne, Governor General of Canada from 1878 to 1883. On its shore sits the prestigious and lovely Chateau Lake Louise.

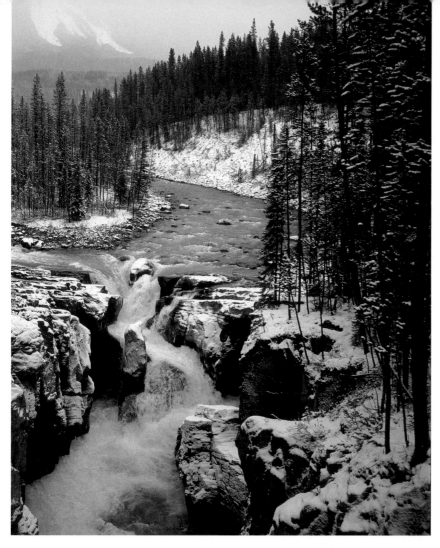

Sunwapta Falls, Jasper National Park, Alberta. Named by climber Arthur P. Coleman after the Indian words for "turbulent water," the river rises on the north flank of Mount Athabasca and flows northwest into the Athabasca River.

Reader's Rock Garden, Calgary, Alberta. Formerly the home of William Roland Reader, superintendent of the Calgary Parks Department from 1912 to 1942, Reader's Rock Garden is known for its unparalleled views of its surroundings, as well as its huge collection of rare shrubs and trees. At its peak, the rock garden covered 1.2 hectares and contained more than 3,000 species of plant life.

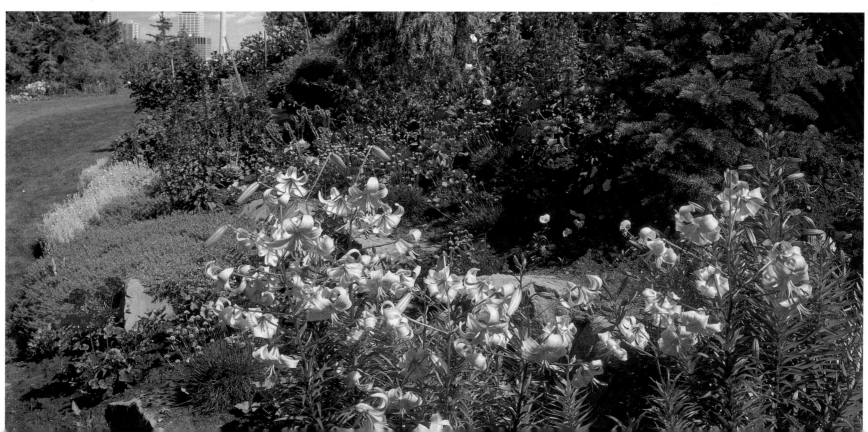

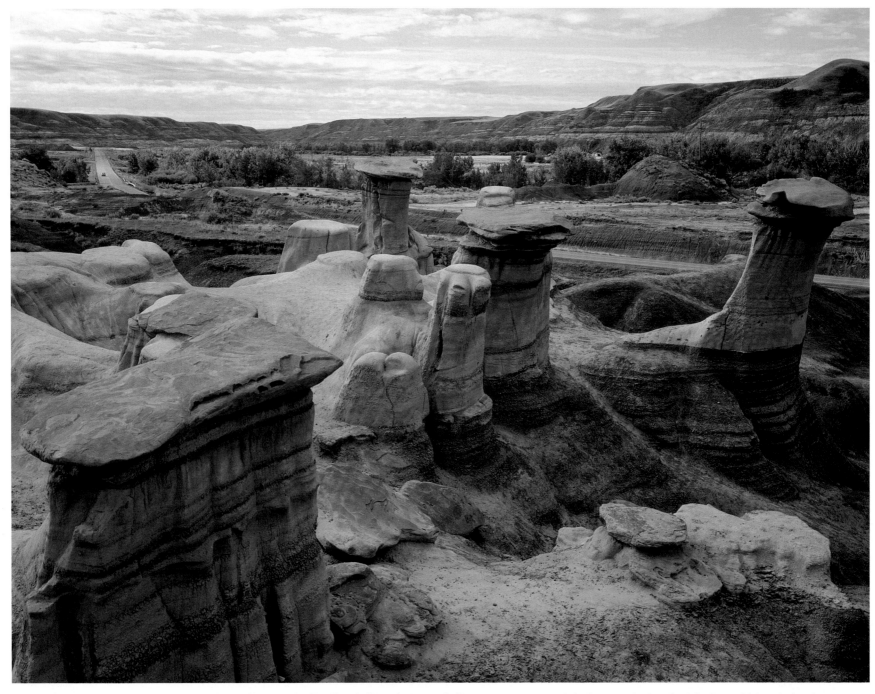

The badlands and hoodoos by Drumheller, Alberta. The "badlands," in the Drumheller area, are part of the huge geologic, physiologic and historic landscape extending from the northwestern United States into the Red Deer River valley of south-central Alberta that is colloquially and factually known as "dinosaur country." Appropriately, the Drumheller area houses a world-class research facility in the Royal Tyrrell Museum of Paleontology, with its outstanding collection of dinosaur skeletons. The Dinosaur Provincial Park, which encompasses the most spectacular part of the Red Deer River valley, was recognized by UNESCO in 1979 and placed on the World Heritage list. Badlands —Hoo Doos Drumheller, Alberta

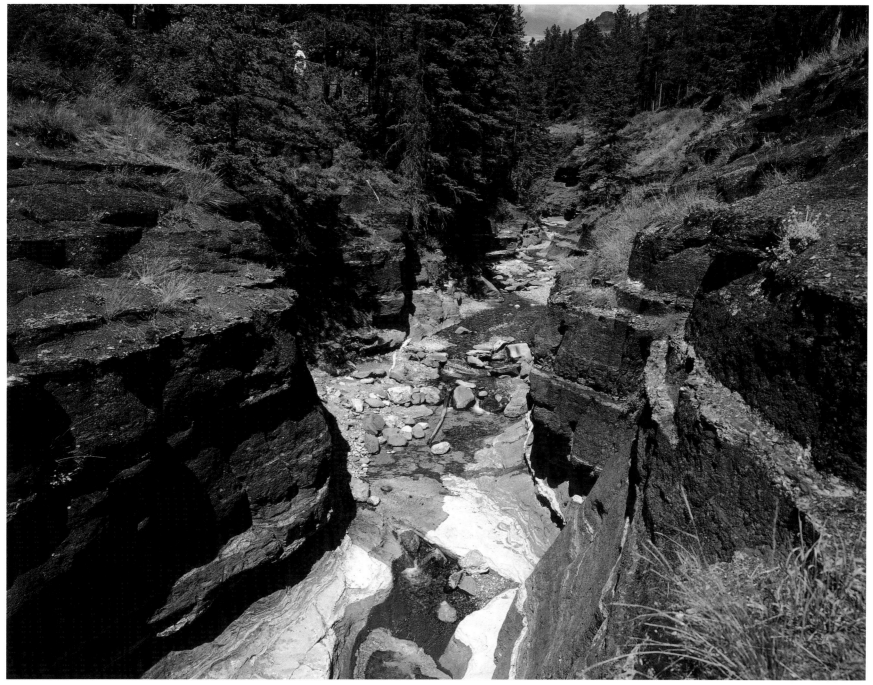

Red Rock Canyon, Waterton Lakes National Park, Alberta. Located in Waterton Lakes National Park, adjoining the south of Glacier National Park in Montana, USA, this canyon comprises a 204-square-mile mountainous area that rises abruptly from the prairies. The mountains within the park are carved out of a series of layered sediments more than a mile thick and include some of the oldest rocks known in Canada's Rocky Mountains. Many visitors remark on the contrasting colours of the layers of exposed red- and green-coloured minerals.

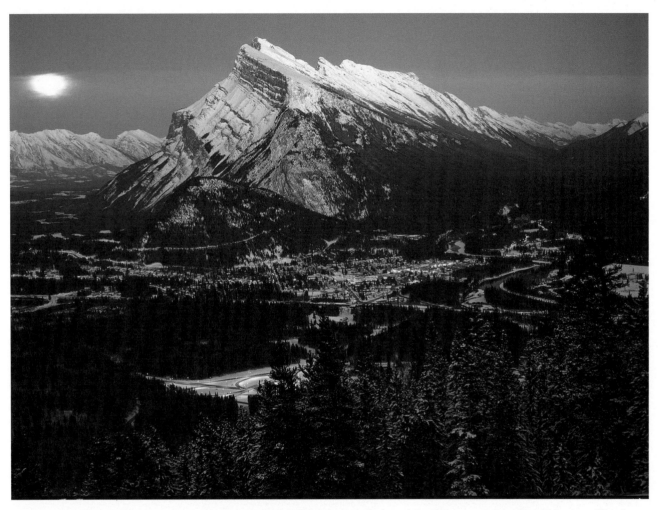

Banff, Alberta. The main town in Banff National Park and the location of the prestigious Banff Springs Hotel.

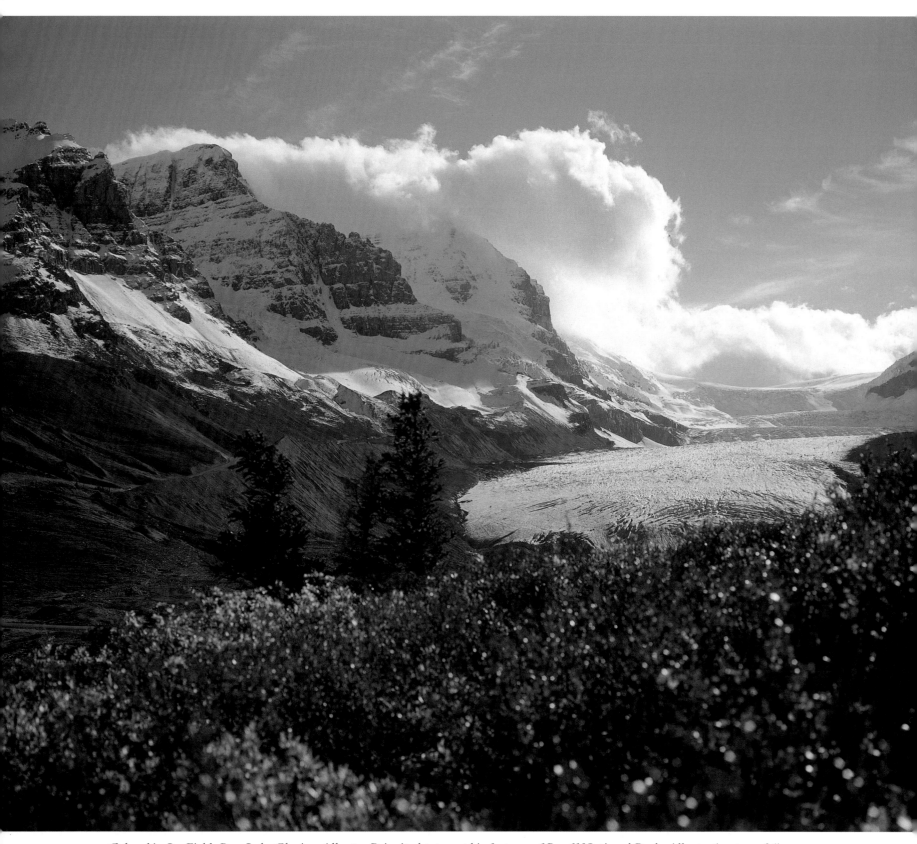

Columbia Ice Field, Bow Lake Glacier, Alberta. Principal topographic features of Banff National Park, Alberta (see page 34).

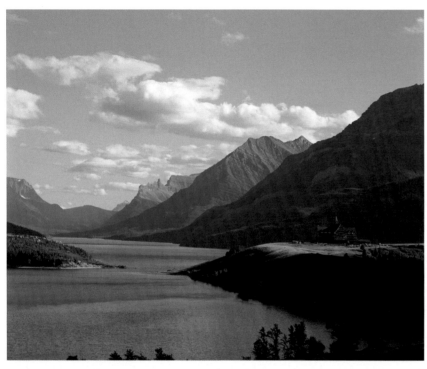

Waterton Lakes National Park, Alberta. Officially known as the Waterton-Glacier International Peace Park, this park was established by legislation of the Parliament of Canada and the Congress of the United States. The world's first such park, the International Peace Park symbolizes the peace and goodwill between the United States and Canada, as exemplified by the world's longest undefended border. The mountains in this photograph are in the United States and form part of the Glacier National Park in Montana.

Mount Rundle, Alberta. (See page 34).

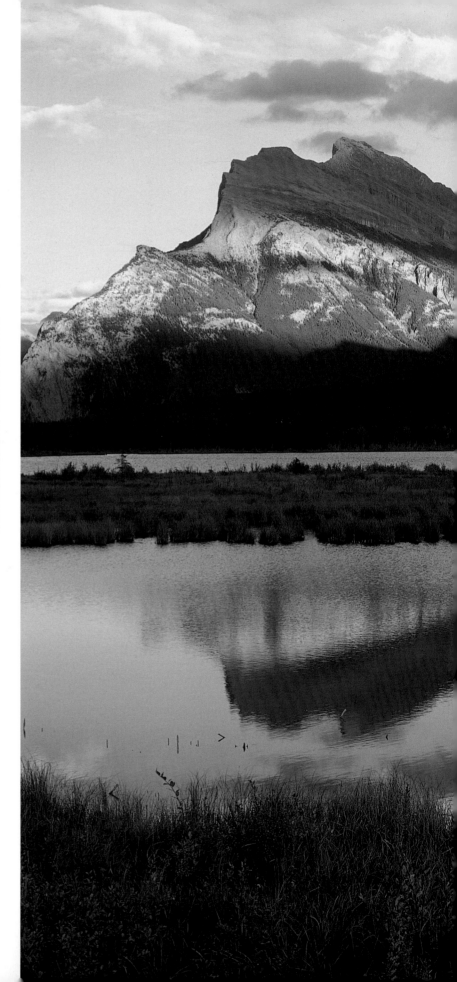

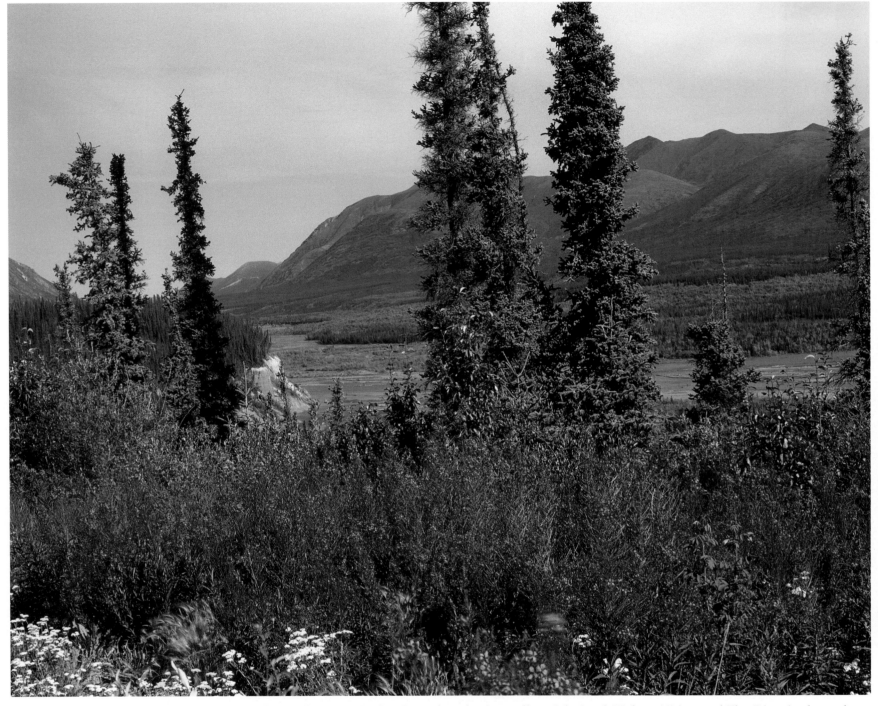

North Nahanni River, Nahanni National Park, Northwest Territories. Centred on the river valleys of the South Nahanni River and Flat River in the southwest part of the Northwest Territories, Nahanni National Park Reserve is an outstanding example of northern wilderness rivers, canyons, gorges and alpine tundra.

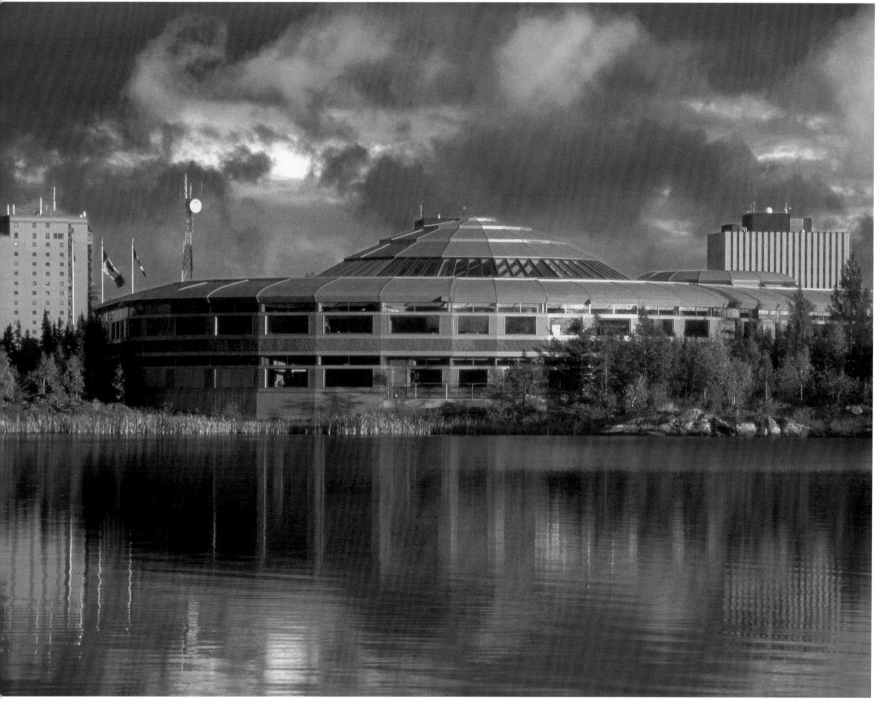

Legislative Assembly, Yellowknife, Northwest Territories. An impressive new Legislative Assembly for the Northwest Territories. The city was established on the north arm of Great Slave Lake in the 1930s, when a gold rush resulted in a boom town at the mouth of the Yellowknife River, itself named after a Chippewa Indian band.

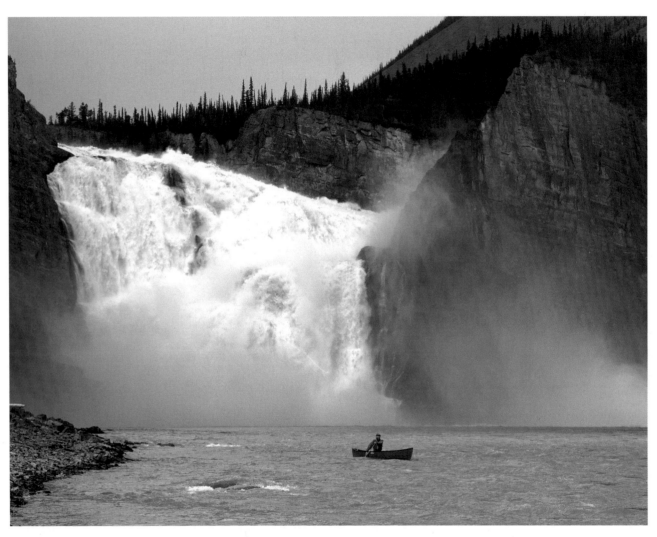

Virginia Falls, Nahanni National Park, Northwest Territories. One of Canada's most spectacular sights, these waterfalls are forty metres high, twice the height of Niagara Falls, and are said to be twice as deadly.

Northwest Territories. Known for its totally natural environment, ice-capped mountains, glaciers, and icebergs, the Northwest Territories are a unique experience.

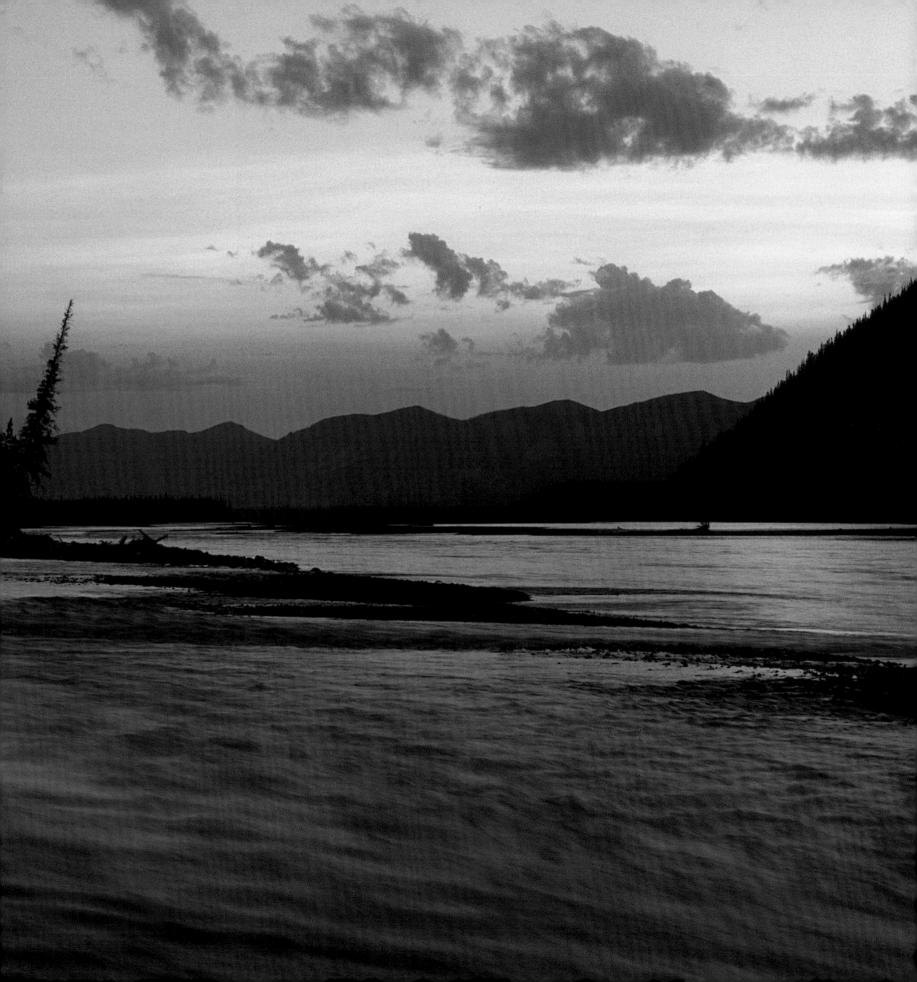

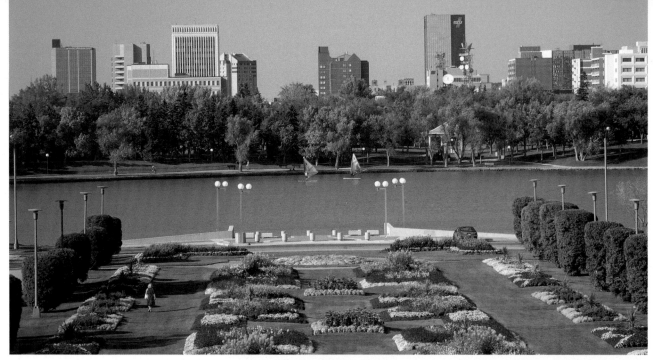

OPPOSITE *Qu'Appelle Valley, Saskatchewan. Cut out 12,000 years ago by meltwaters from a retreating glacier that left a wide valley with only a small stream, surrounded by low, round-topped hills. According to legend, a man in his canoe heard his name called. He called back, "Qu'appelle?" ("Who calls?"), but only an echo answered him. On returning home, he found his sweet-heart lifeless—she had called his name moments before dying.*

Regina, Saskatchewan. Regina was founded in 1882 as the capital of the Northwest Territories and named by the Marquess of Lorne, then Governor General of Canada, in honour of his mother-in-law, Queen Victoria. When the province of Saskatchewan was created in 1905, Regina became its capital. This provincial capital is renowned as the home of the RCMP, as well as the Saskatchewan Wheat Pool.

Lebret, Saskatchewan. A historic village located in the Qu'Appelle Valley on Mission Lake, named in 1886 by Senator Girard after its first postmaster, Father Lebret, who had established a residential school for Métis in the village in 1884.

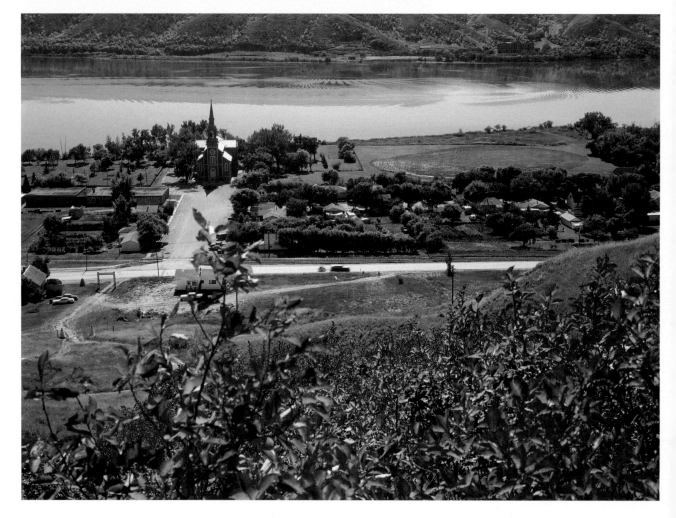

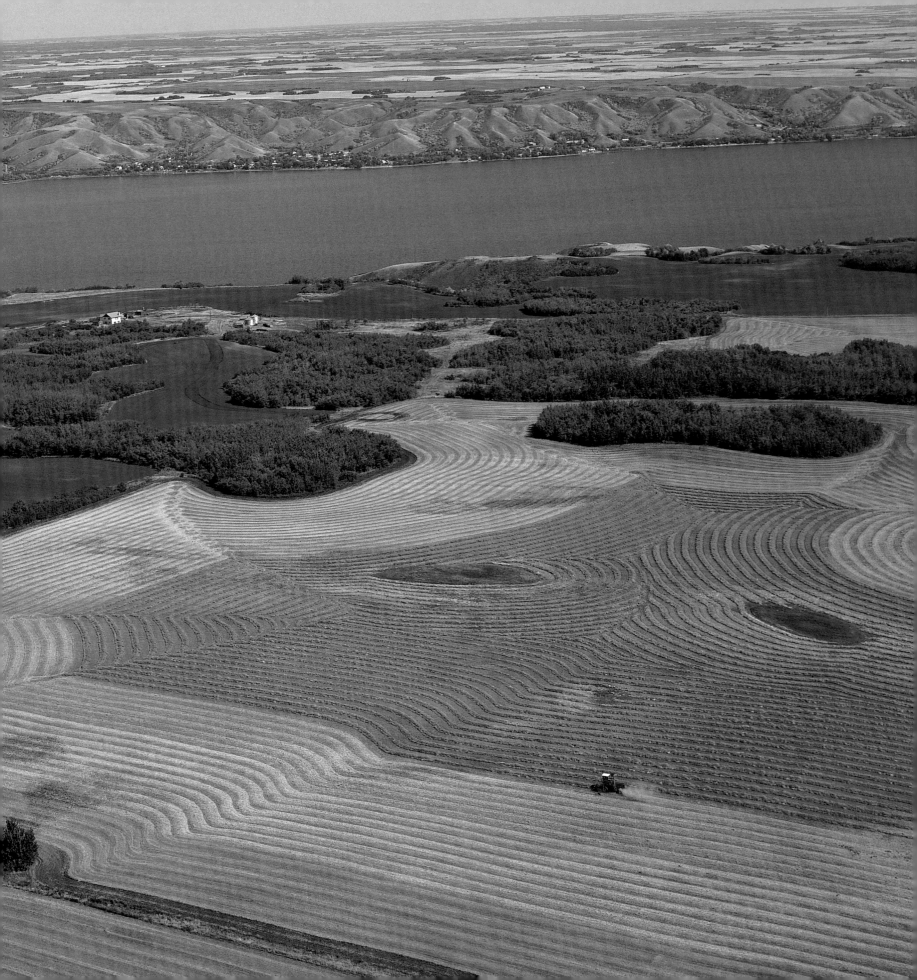

*Nistowiak Falls, on the Churchill
River, Saskatchewan. Arguably
Saskatchewan's most famous
waterfall, Nistowiak Falls is a
ten-metre drop on the Rapid
River as it runs into the Churchill
River below Stanley Mission.*

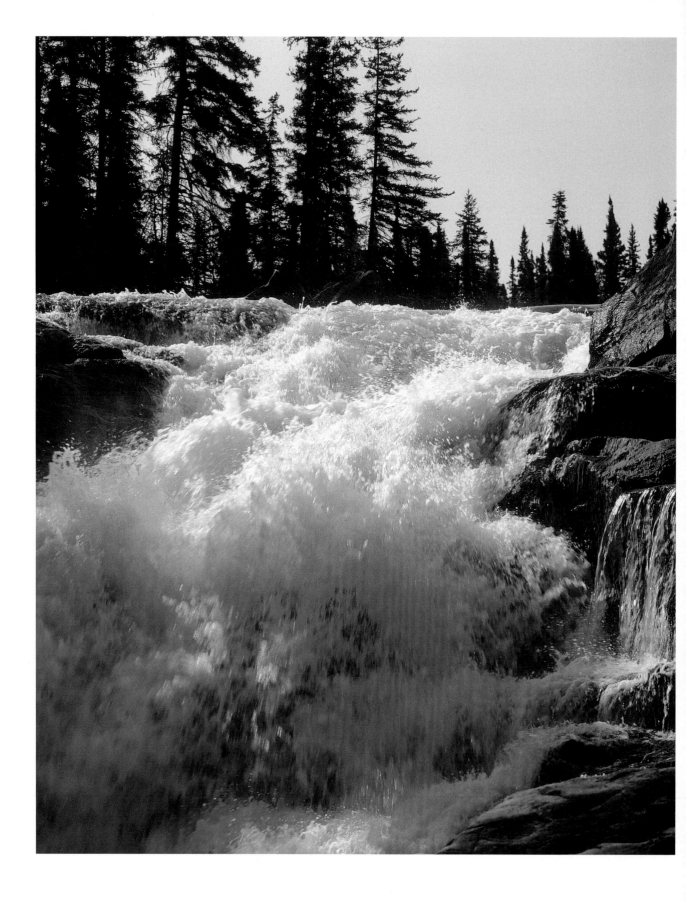

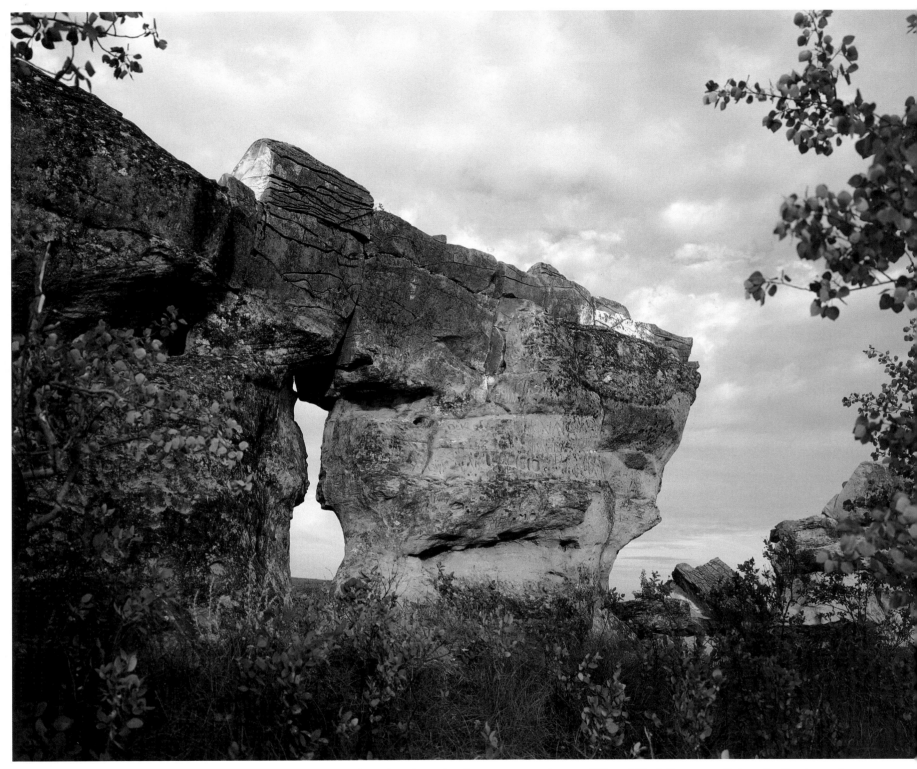

Roche Percée, Saskatchewan. A hole is clearly visible near the right end of the rock, whose name translates to "Pierced Rock," once a religious site for the native Assiniboine (Assnipwan, or Stone Sioux) tribes in this area. In the spring and fall, they would perform religious ceremonies here and leave gifts to "Manitou" (one of the deities or spirits dominating the forces of nature).

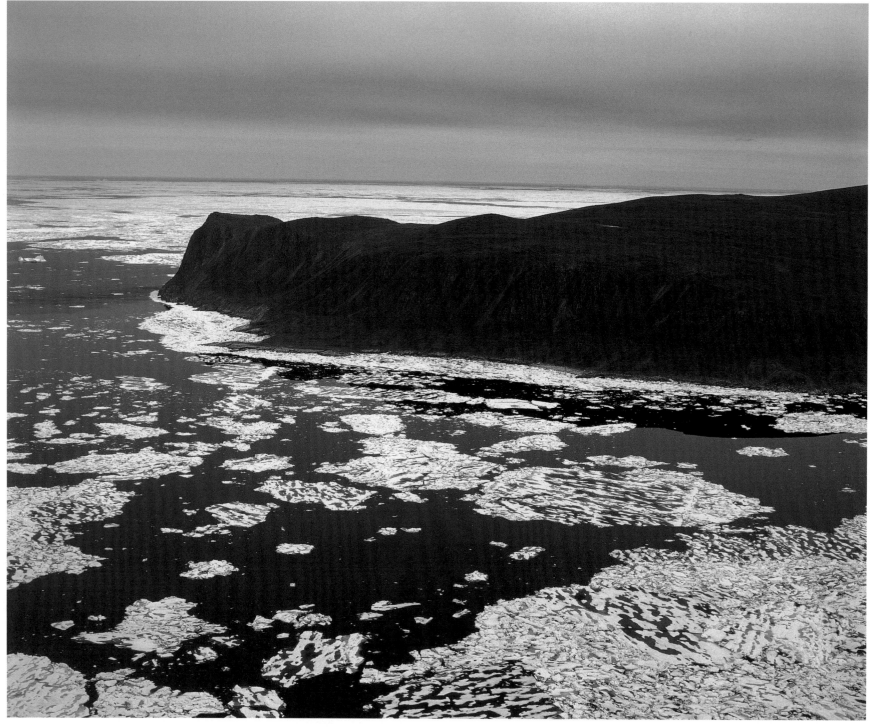

Pangnirtung Fjord, Baffin Island, Nunavut. The name derives from the village on its shore. Pangnirtung, which means "the placxe of th bull caribou," is located on a narrow coastal plain against a spectacular drop of high mountains and a winding river valley. Legend says a hunter named Atagooyuk gave the place its name well over 100 years ago when caribou had not yet changed their patterns of migration as a result of the incursions of man.

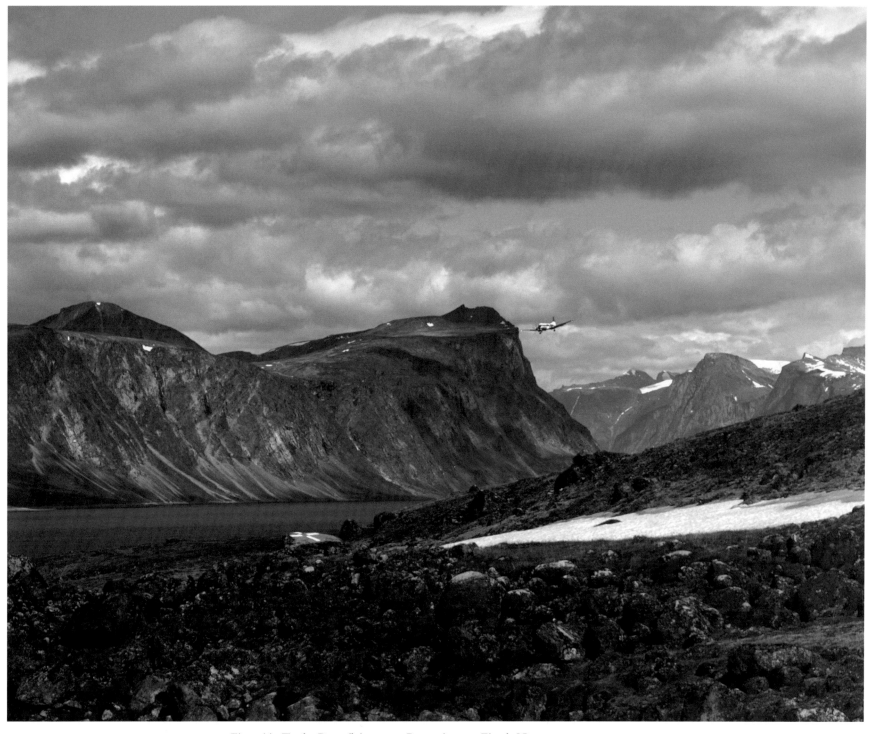

First Air Turbo Prop flying over Pangnirtung Fiord, Nunavut.

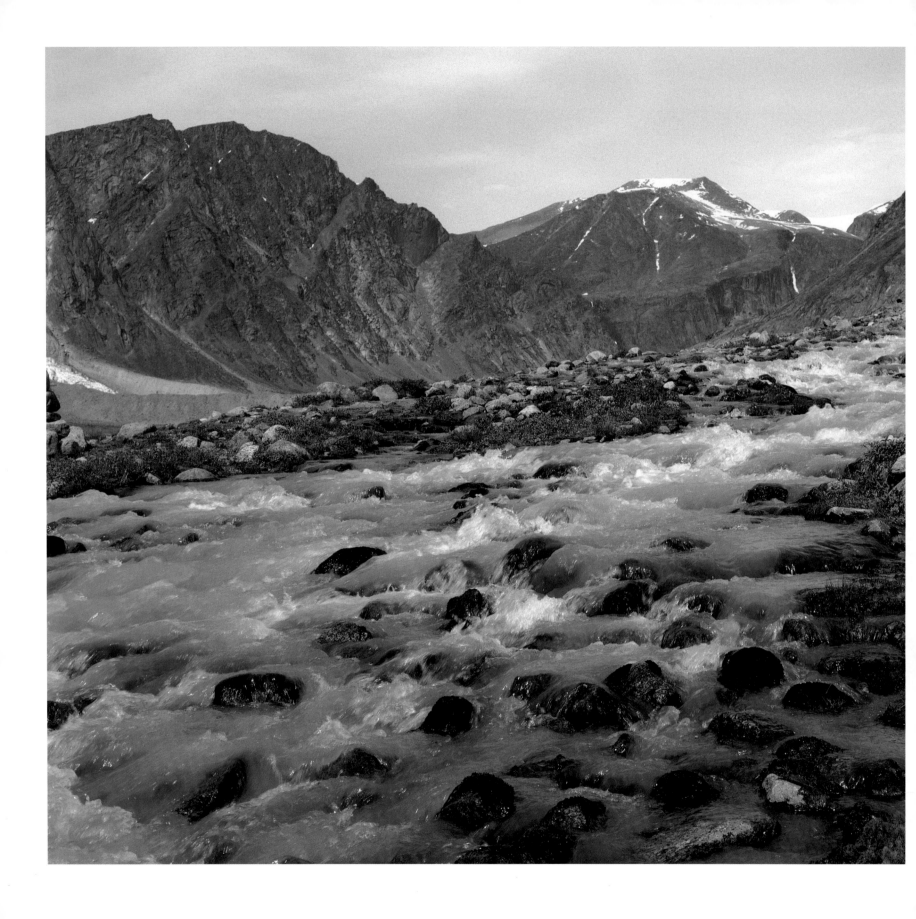

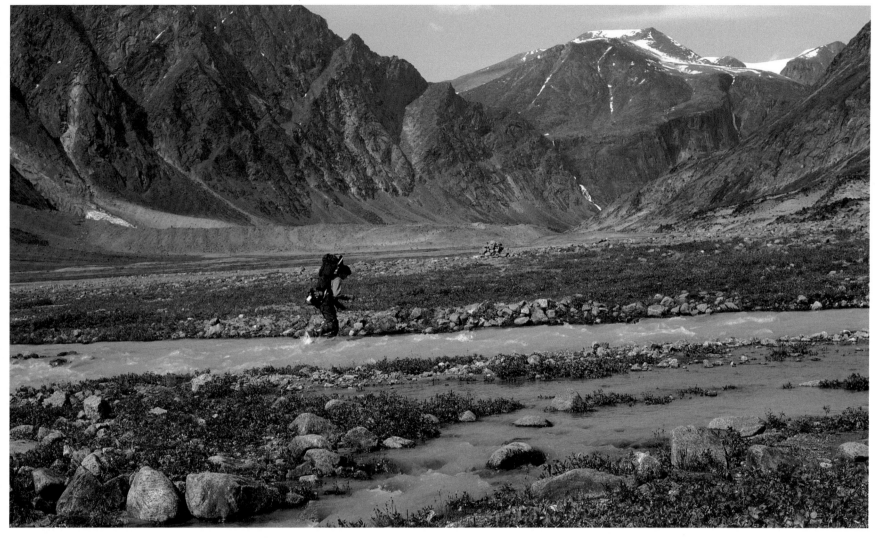

Pangnirtung, with the Weasel River and Auyuittuq National Park in the background, Nunavut. Established in 1921, originally as a Hudson's Bay Company post, Pangnirtung is on the south side of the Cumberland Peninsula and the north side of the Pangnirtung Fjord on Baffin Island.

OPPOSITE *Auyuittuq National Park, Baffin Islands, Nunavut. This park reserve is located north of Pangnirtung on the east side of Baffin Island. It was established as Baffin Island National Park in 1972 and three years later renamed Auyuittuq National Park, the name being derived from the Inuktitut word auyttiq,* [is part of this word missing?] *"land of the big ice," or, in a more literal translation, "place that does not melt."*

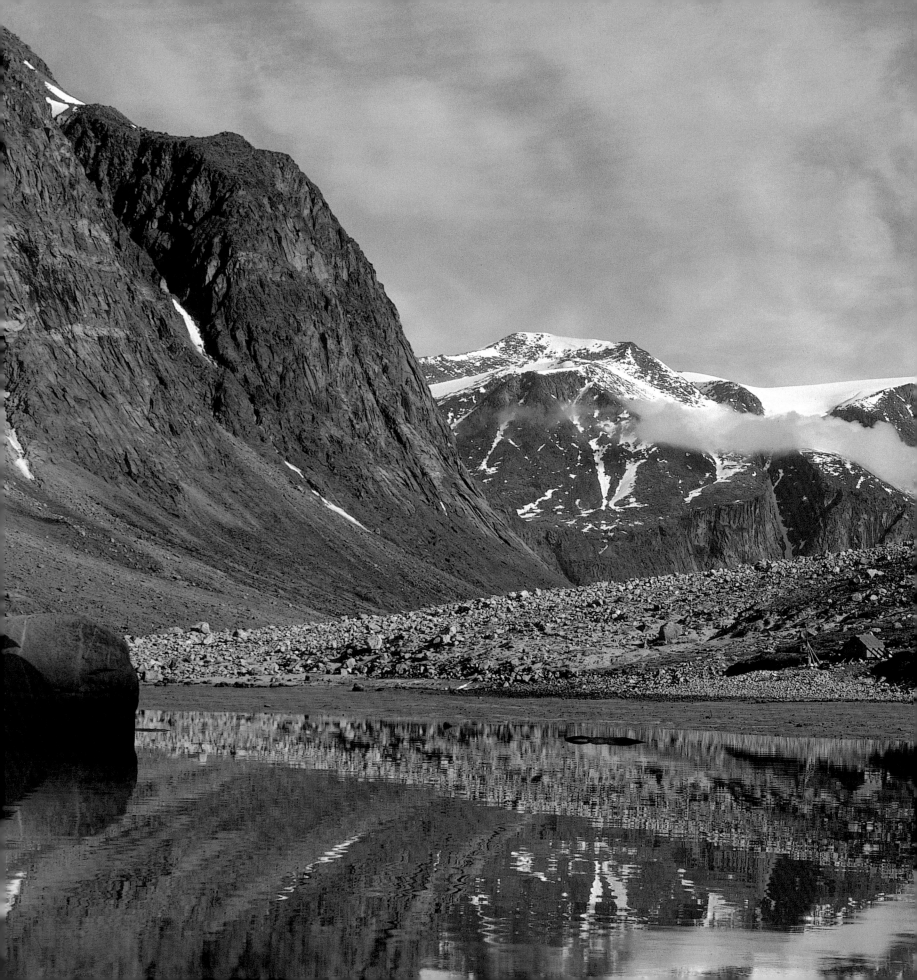

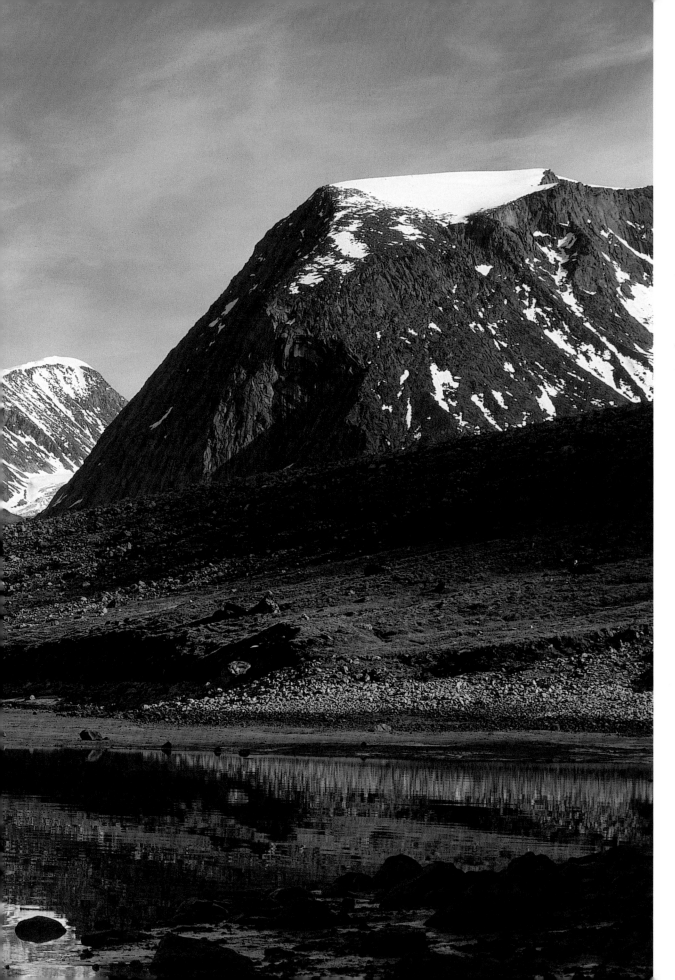

Auyuittuq National Park, Nunavut. Pronounced "ow-you-ee-tuk," this park was the first national park north of the Arctic Circle and covers 19,500 square kilometres of deep mountain valleys, dramatic fiords, ancient glaciers and spiny peaks. Plants grow low to the ground and are predominately made up of lichens, mosses, sedges and dwarf willows or smaller patches of flowering plants.

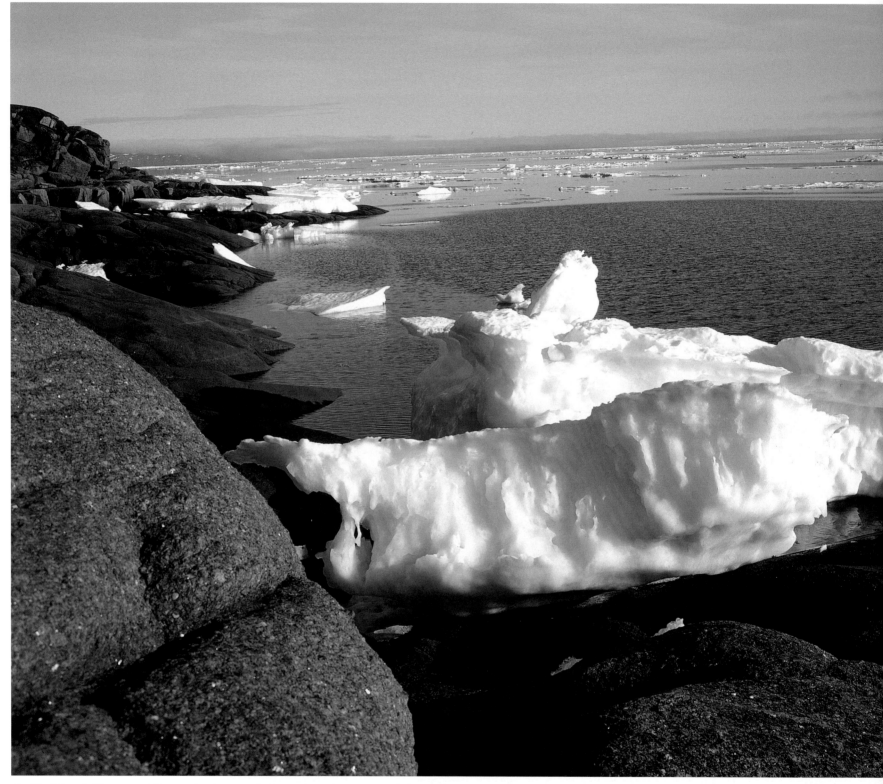

Baffin Island, Nunavut. Up north, there are lodges scattered on remote lakes and coasts from the Mackenzie Mountains to the fjords of Baffin Island, where fishing is superb (Arctic char, Arctic grayling and great northern pike, among others).

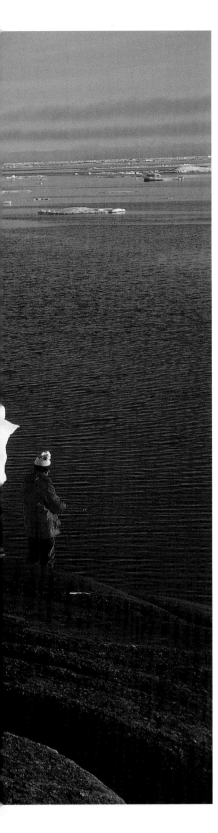

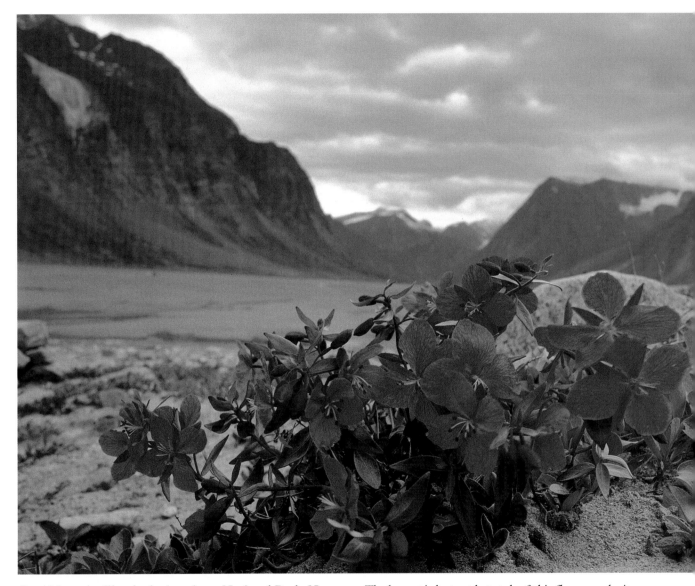

Broad-leaved willow herb, Auyuittuq National Park, Nunavut. The large pink-purple petals of this flower make it the showiest in the park. A relative of the southern fireweed, it is shorter and bushier because of the arctic climate. Inuit sometimes eat its leaves and flowers.

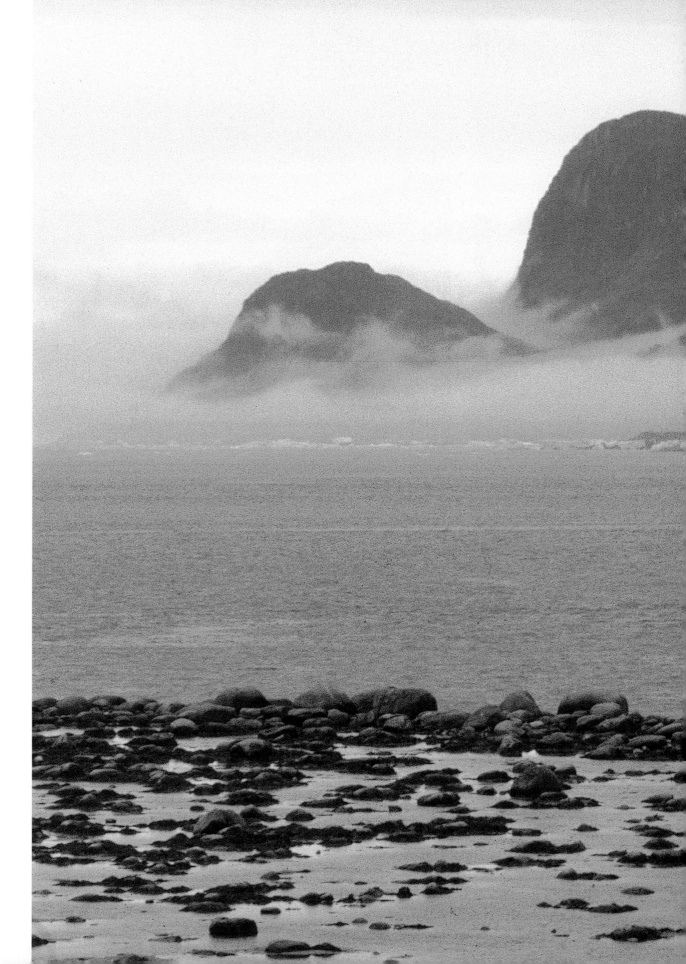

Inukshuk—landmark of the
Arctic—Nunavut. An inukshuk,
meaning "to act in the capacity of
a human," is a stone figure that
was used as a navigational aid,
campsite or hunting mark, or to
serve as a reminder of special occa-
sions.

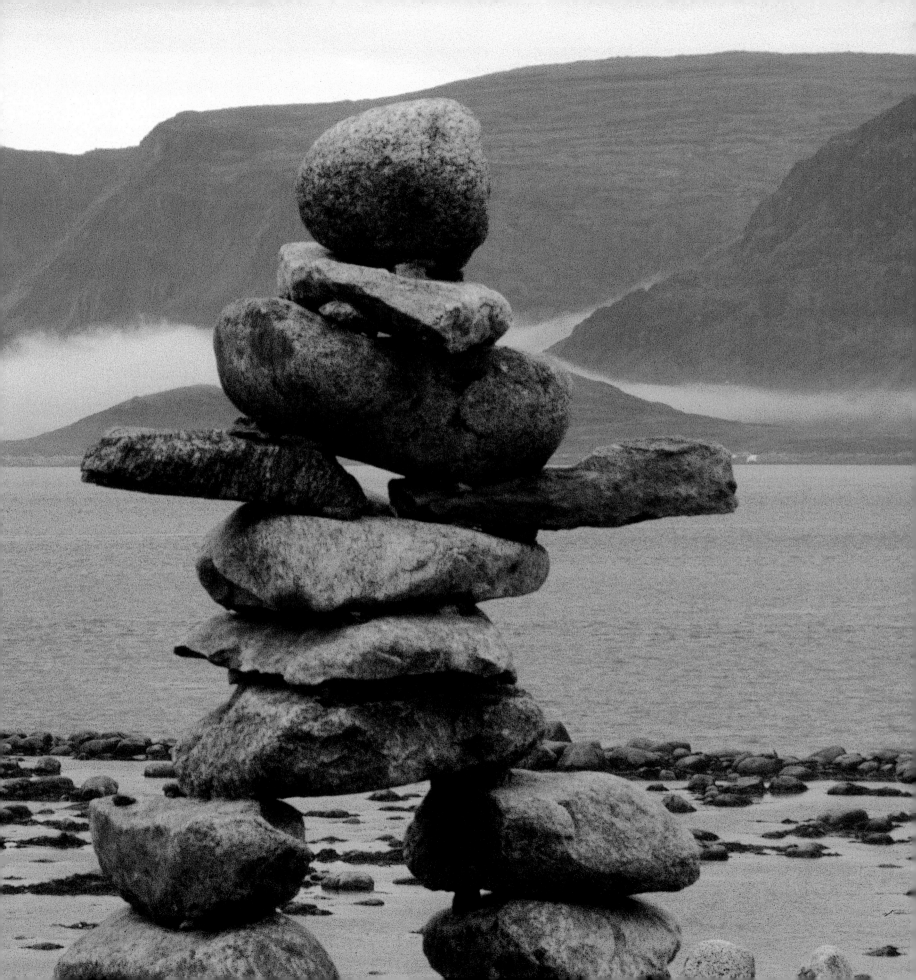

Falcon Lake, Whiteshell Provincial Park, Manitoba. Sunset over the lake.

Rouge River, Winnipeg, Manitoba. The Red River of the North forms the boundary between the states of Minnesota and North Dakota south of the 49th parallel, then flows north through Winnipeg to Lake Winnipeg. Its Ojibwa name signifies "red water river," likely after the red-brown silt that it carries, and indeed the Cree word that provides the name Winnipeg means "murky water." In 1738–9, explorer Pierre Gaultier de la Vérendrye called it Rivière Rouge, which remains one of its official names.

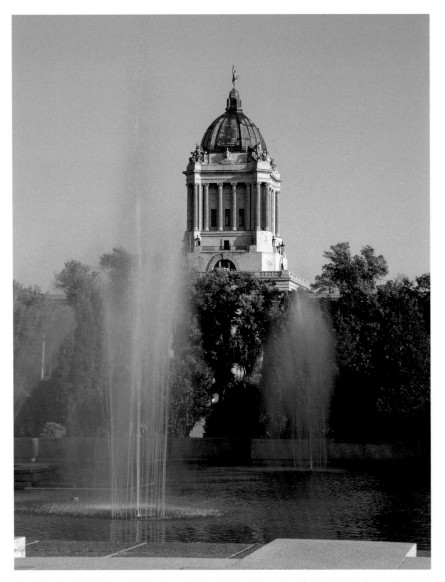

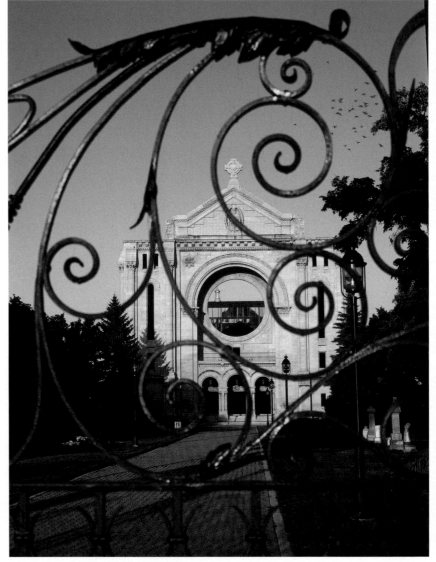

Legislative Building, Winnipeg, Manitoba. Completed in 1919, the Legislative Building was constructed of Tyndall limestone quarried a few miles north of Winnipeg. This particular stone, with its fossil inclusion and its distinctive colour, has been widely used in institutional buildings, banks and post offices from coast to coast across Canada. The Winnipeg building is built in the form of an "H" with a dome in the centre. Above the dome stands the "Golden Boy," a gold-plated bronze statue clutching a sheaf of wheat in one hand and a torch in the other to symbolize Manitoba's glowing future. Above the main entrance (on the north side), a pediment depicts Canada's motto, "From Sea to Shining Sea." The main entrance hall opens onto a stairway flanked by two bronze buffalo, the provincial emblems.

Ruins of St. Boniface Cathedral, Winnipeg, Manitoba. Six churches have stood in this site since 1818. In 1968, fire largely destroyed the fifth building except for its stone facade (shown here), which stands immediately in front of a new cathedral. The cemetery contains the grave of the Métis leader Louis Riel.

OPPOSITE *Manitoba. The ever-changing clouds and sunlight of a summer afternoon in Manitoba.*

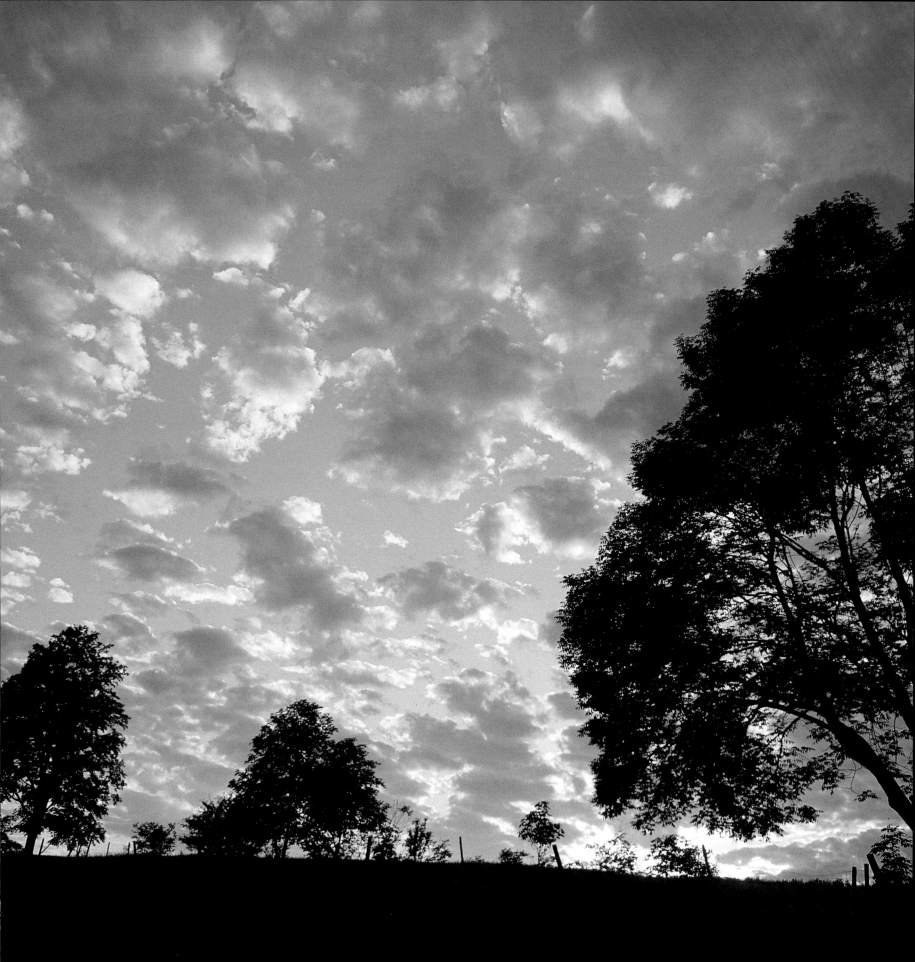

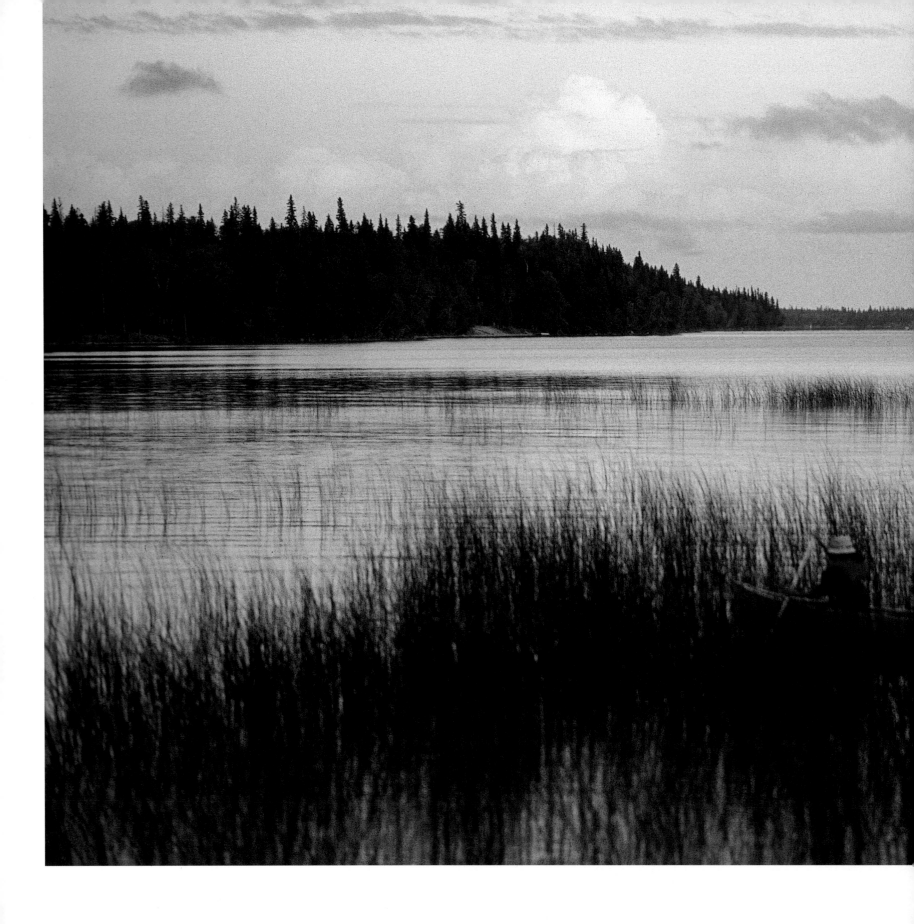

Early-morning canoeists, Riding Mountain National Park, Manitoba. Established in 1929–30, the park is situated northwest of Winnipeg on a rolling plateau 1,000 feet above the vast prairies that is part of the Manitoba Escarpment—a jagged, 1,000-mile ridge winding across North Dakota, Manitoba and Saskatchewan that is a series of hills cut by many rivers, rather than a continuous ridge.

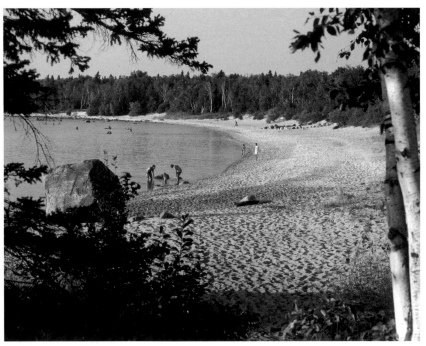

Falcon Beach, Manitoba. A nice sandy beach on Falcon Lake in Whiteshell Provincial Park.

Pisew Falls, on Grass River, Manitoba. Pisew Falls, named from the Cree for "the hiss of a lynx," is the third-largest waterfall system in Manitoba, with an average of 90,000 litres of water cascading over a thirteen-metre drop every second, then shooting down a gorge.

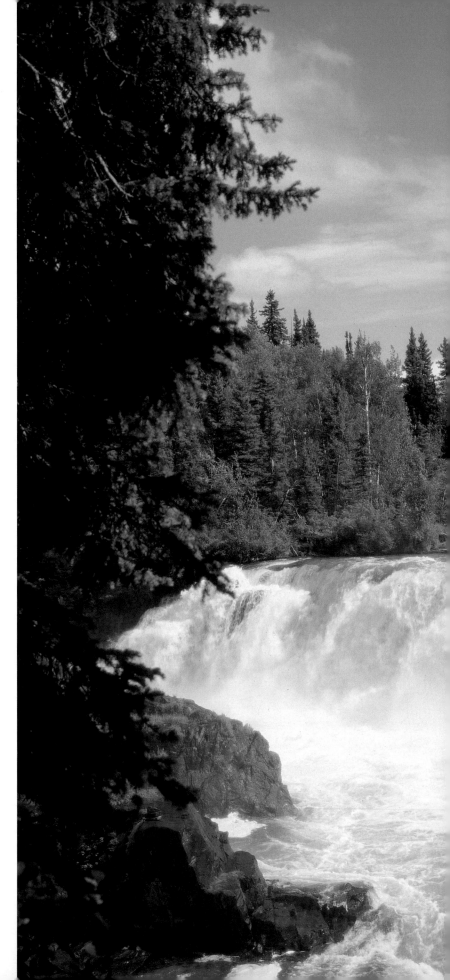

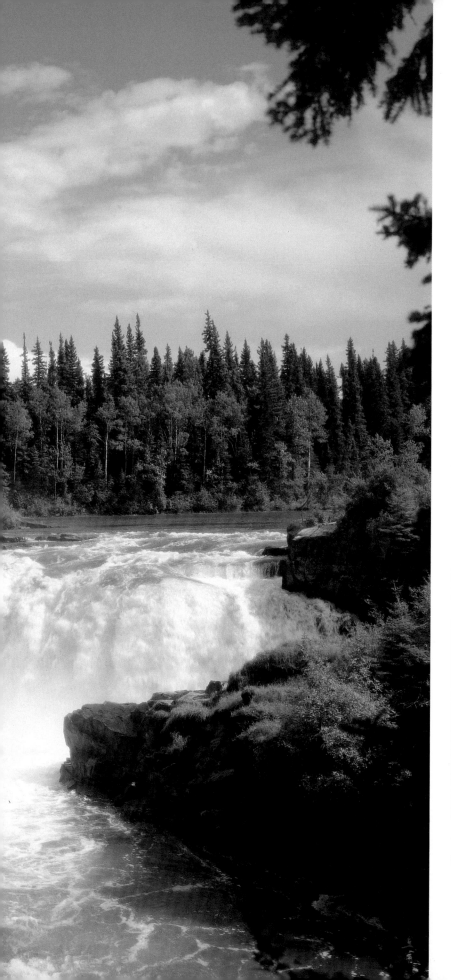

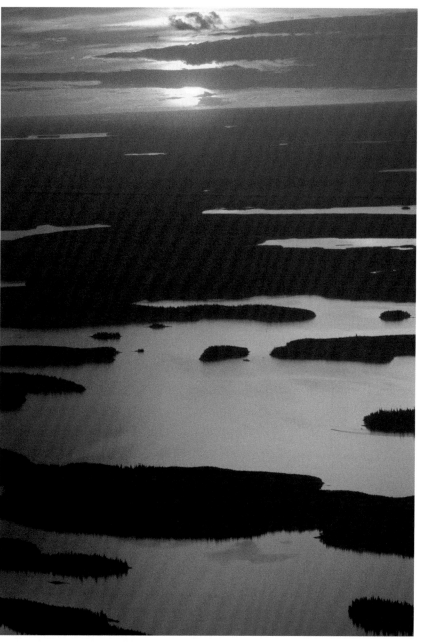

Paint Lake, near Thompson, Manitoba. With its countless islands, this lake is the centrepiece of the Paint Lake Provincial Park.

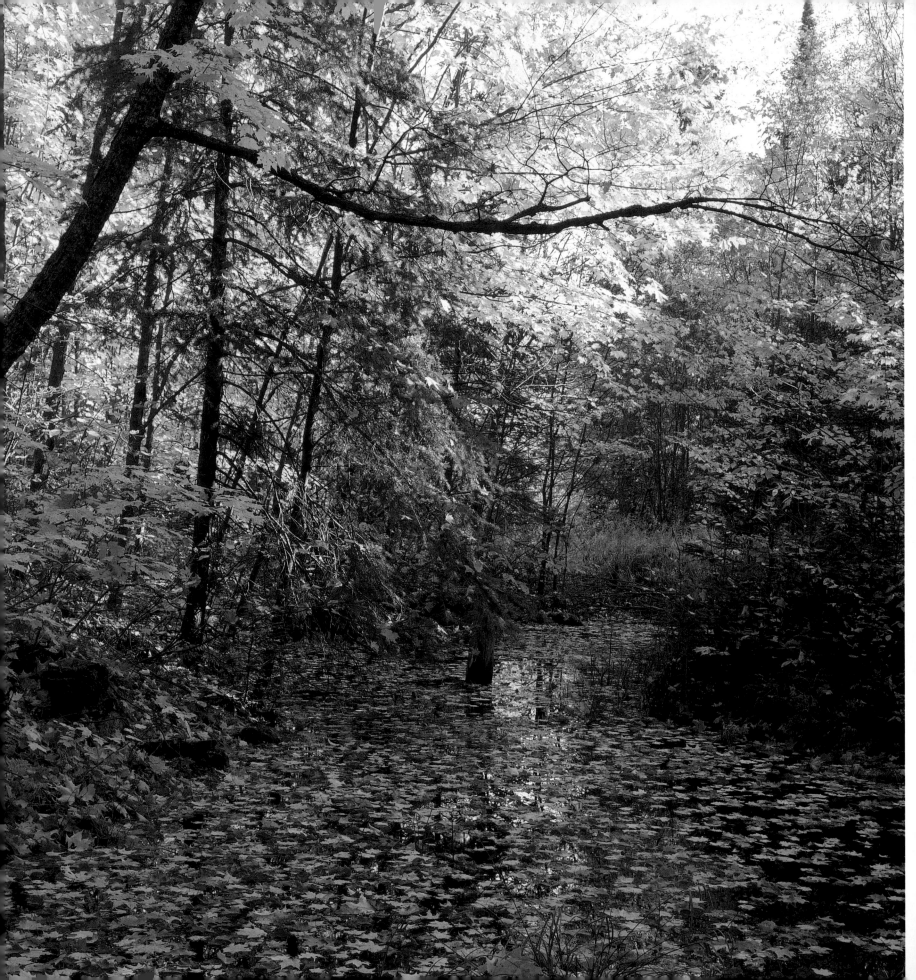

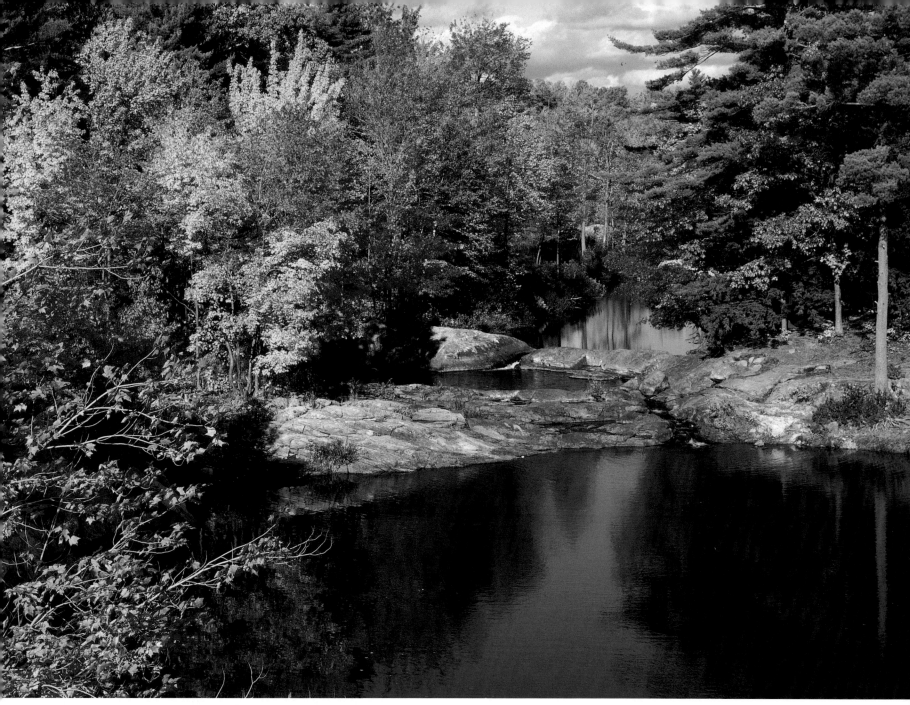

OPPOSITE *Autumn in Algonquin Provincial Park, Ontario. Algonquin Park— miles north of Toronto and 105 miles west of Ottawa on a height of land between the Ottawa River and Lake Huron that has been preserved from exploitation for nearly a century—is the largest and most important park in Ontario. It was made famous by the Group of Seven, who forged a uniquely Canadian art by painting, in a then revolutionary way, the colours and landscapes of the country's parks, including Algonquin Park, in the second quarter of the twentieth century.*

MacDonald River, Muskoka, Ontario. The Muskokas is a vast district of 1,600 shimmering lakes, thundering waterfalls and sheer granite cliffs, fragrant pine forests and dense maple forests that turn crimson and gold in the autumn, all wrapped in pure clean air from way above sea level (in some places, 1,296 feet). The Muskoka lakes constitute Ontario's most popular vacation region.

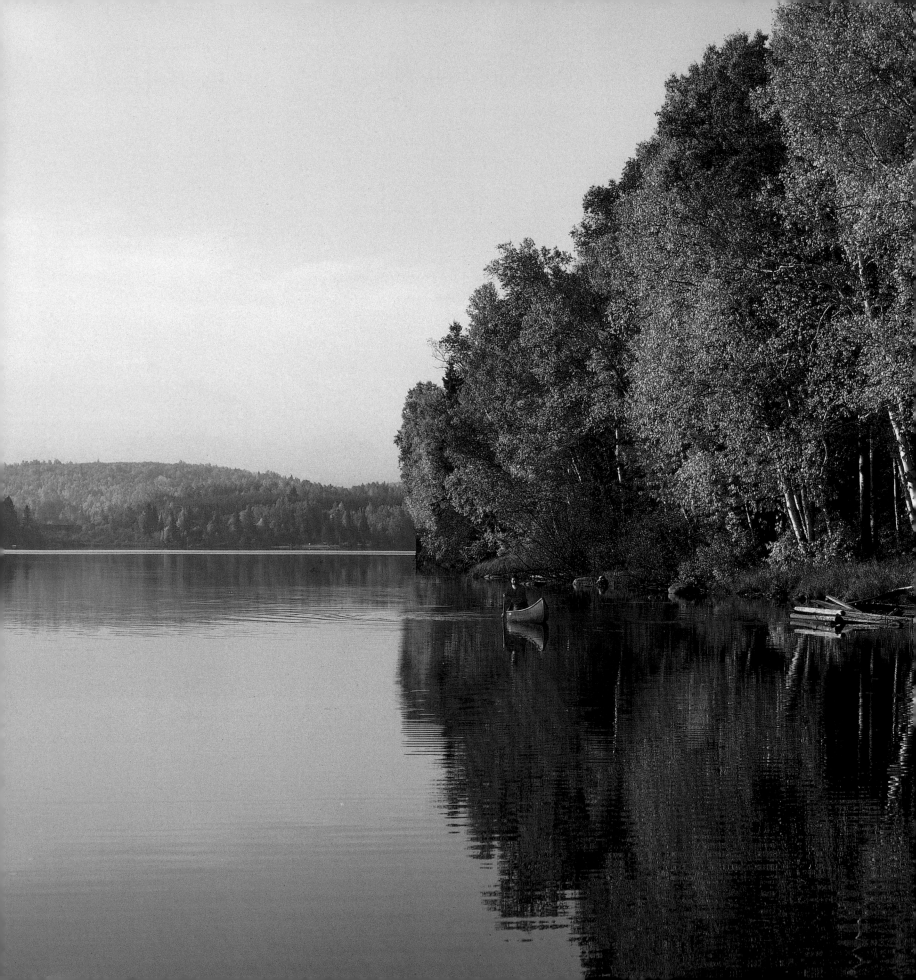

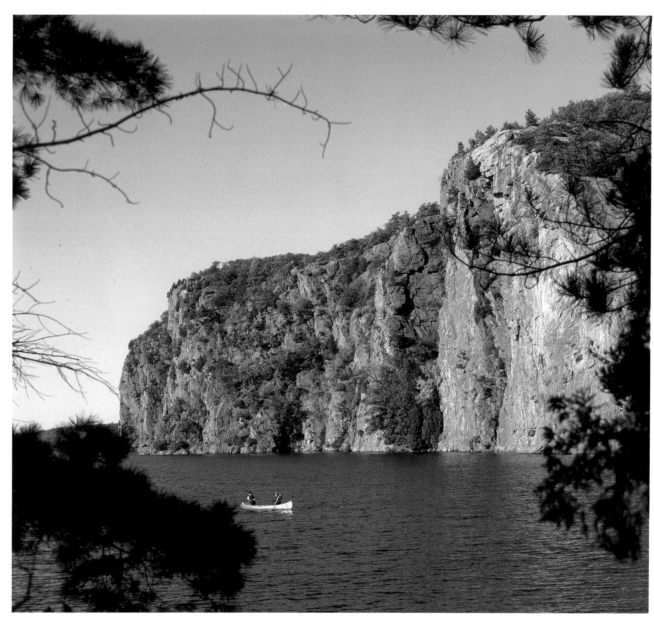

Bon Echo Provincial Park, Ontario. Situated 150 kilometres west of Ottawa, Bon Echo is well-known for the existence of a number of Algonkin pictographs—accessible only by water—on a 115-metre cliff on the east side of Mazinaw Lake. From the top of the cliff, sounds echo across the narrows, hence the name "Bon Echo."

Algonquin Provincial Park, Ontario. Algonquin Park was established in 1893 to provide a wildlife sanctuary and, by excluding agriculture, to protect the headwaters of the five major rivers that flow from the park.

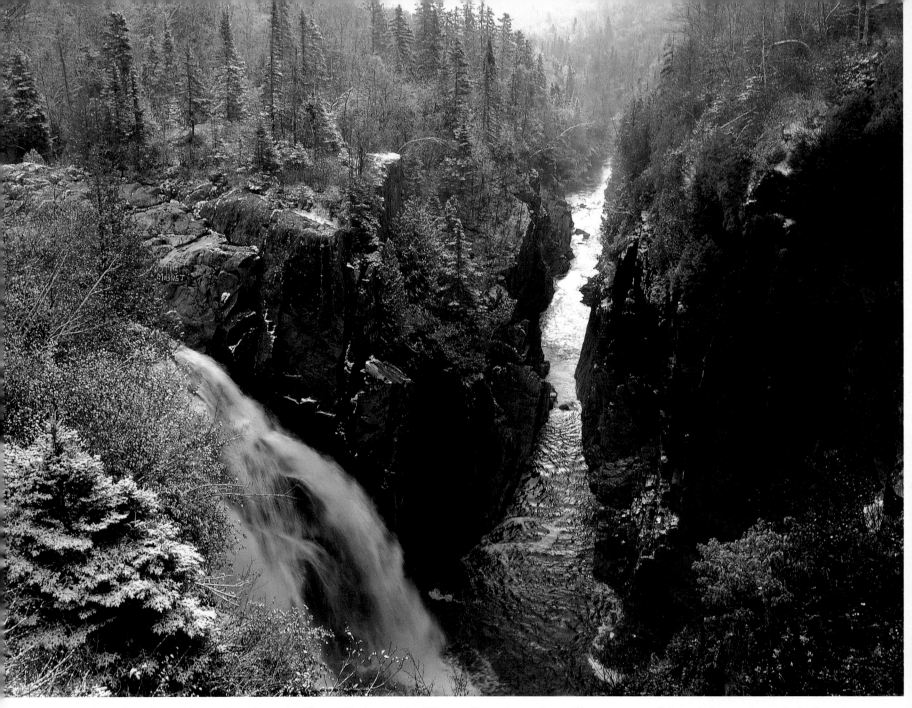

Aguasabon River Gorge, Aguasabon, Ontario. These falls, just south of Terrace Bay, plunge down thirty metres and force their way out to Lake Superior. The walls of the gorge are reddish granite, with big cracks and sheets from long-ago earth movement. The water is controlled upstream by a hydro dam.

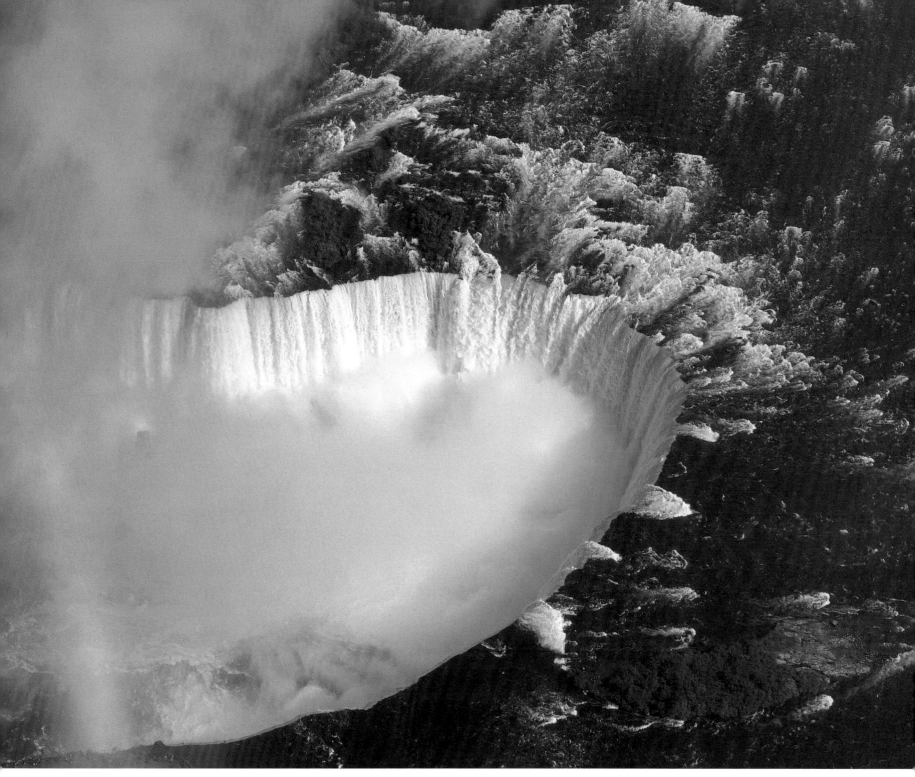

Niagara Falls, Ontario. Roughly halfway along the course from Lake Erie to Lake Ontario, the Niagara River suddenly changes its level by plunging over an immense cliff, creating one of the earth's great natural wonders. These famous falls are the most visited in the world, attracting more than 12 million people a year. There are, in fact, two sets of falls, separated by tiny Goat Island, which stands at their brink. The Canadian, or Horseshoe Falls, named for their shape, contain 90% of the water that flows down the river.

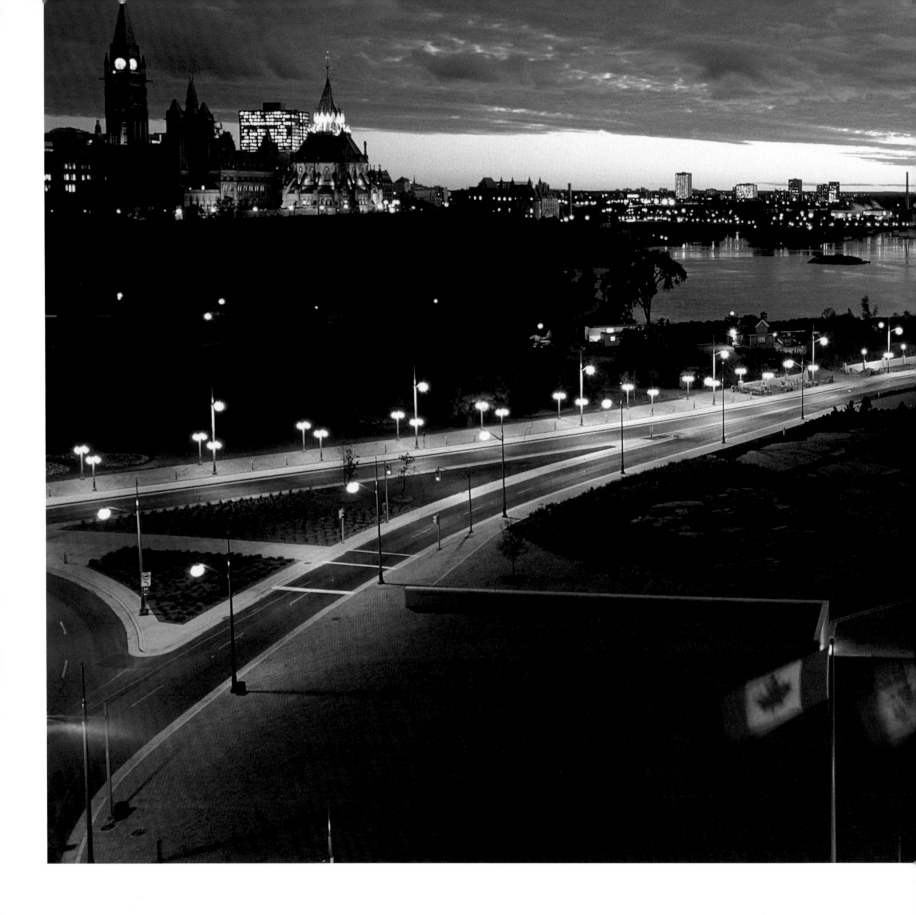

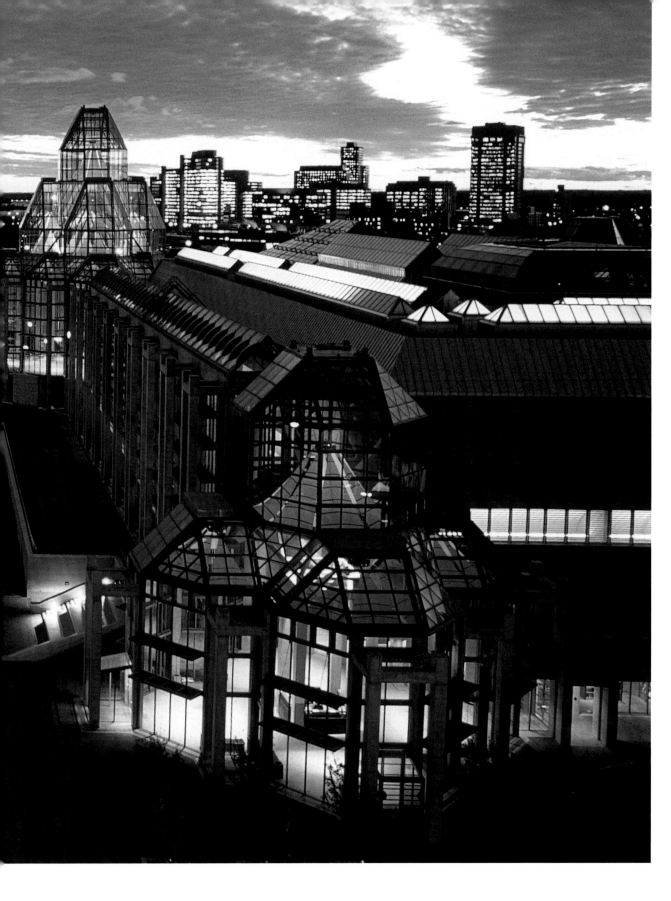

National Gallery of Canada, Ottawa, Ontario. This magnificent glass, granite and concrete building capped by prismatic glass "turrets" rises on the banks of the Ottawa River, across from the Victorian Gothic Parliament Buildings. Its bold beauty, light and airy exhibit spaces, and tranquil interior courtyard provide a unique setting for its remarkable collection.

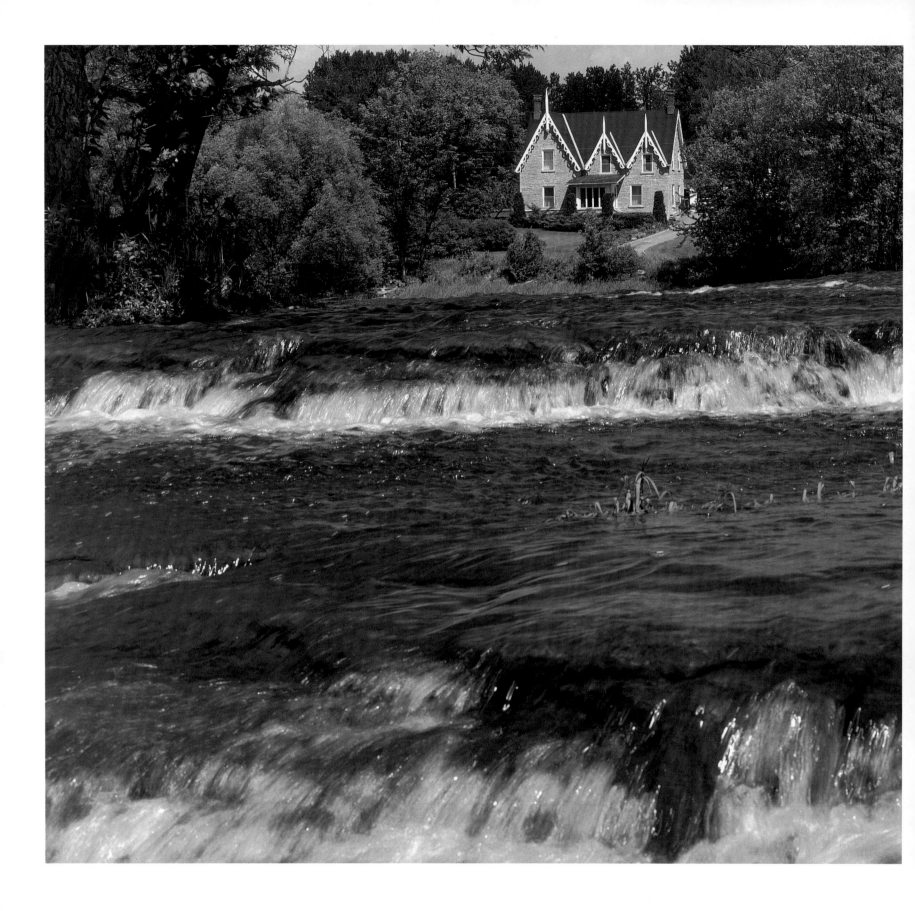

OPPOSITE *Old stone house on Mississippi River, Pakenham, Ontario. The valley of Pakenham was named after General Sir Edward Michael Pakenham (1778–1815), who was killed in the Battle of New Orleans. The village is noted not only for its old stone houses, but also for its five-arched stone bridge, the only one in North America, and for having Canada's oldest general store, established in 1840.*

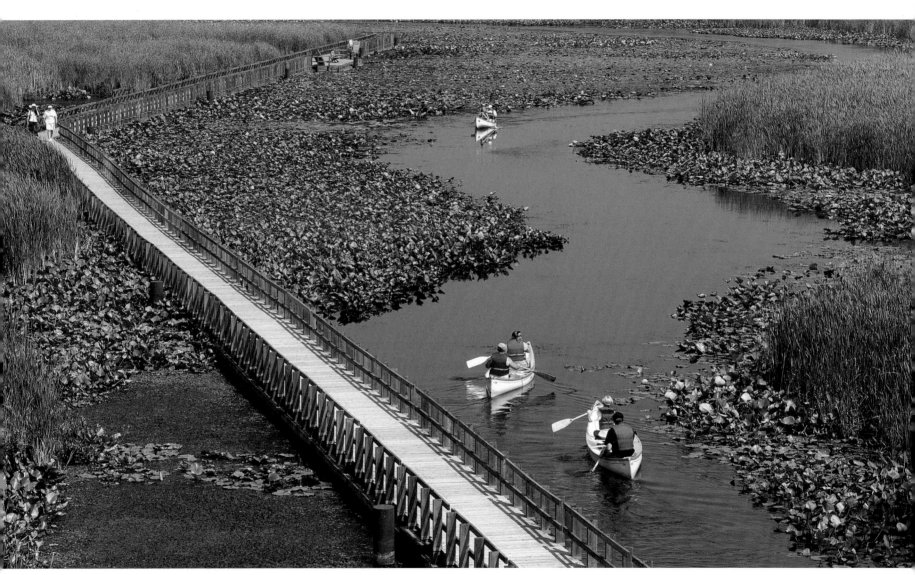

Boardwalk at Point Pelee National Park, Ontario. Situated on a pointed peninsula extending into Lake Erie, Point Pelee National Park is one of the few places where the true deciduous forest of eastern North America still exists. The peninsula took its shape 10,000 years ago, when wind and lake currents deposited sand on a ridge of glacial till under the water of Lake Erie, and it is an ornithologist's paradise.

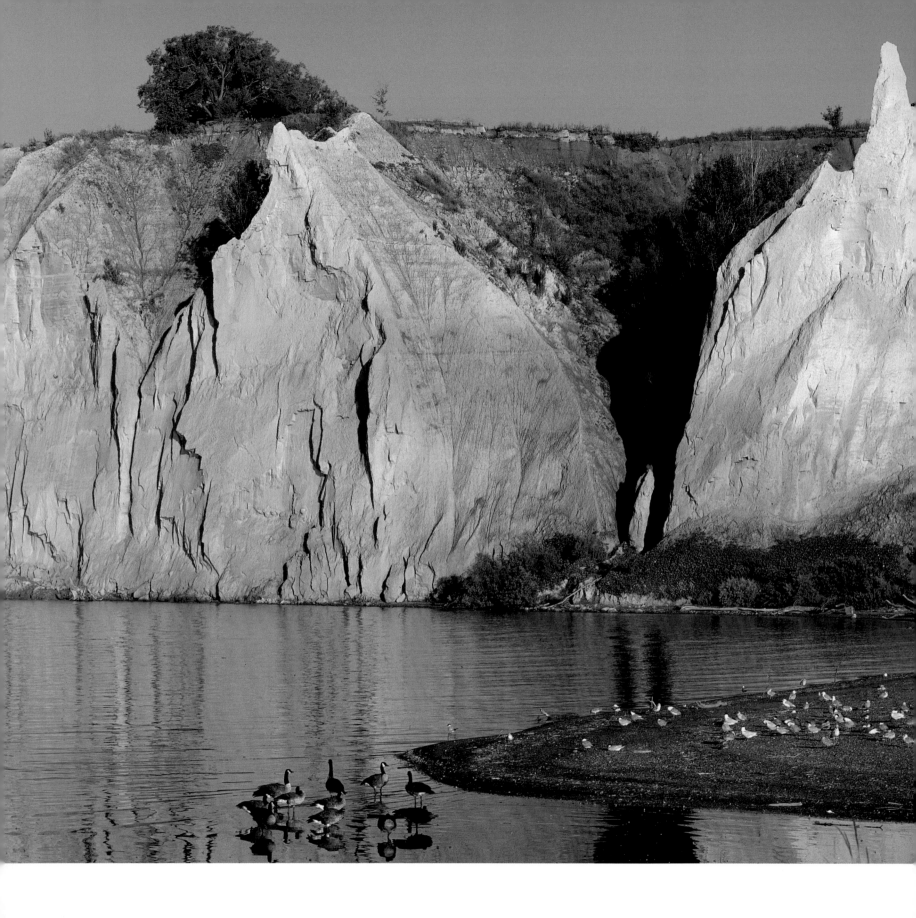

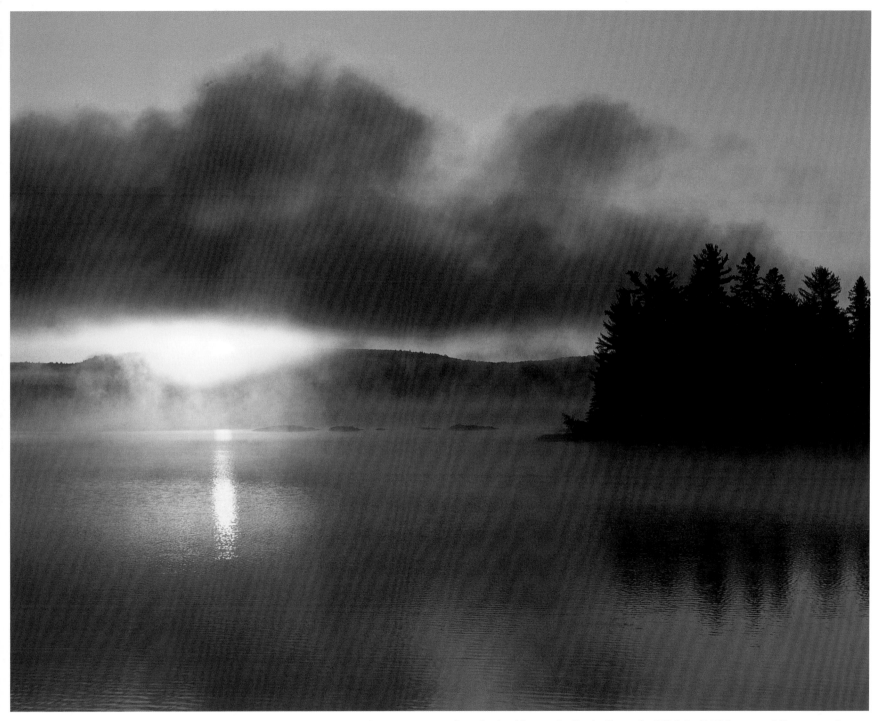

Scarborough Bluffs, Lake Ontario, Ontario. The impressive bluffs of Scarborough, now part of Metropolitan Toronto, reminded Lieutenant Governor Simcoe's wife of the impressive cliffs of Scarborough in North Yorkshire, England—hence the name.

Sunrise in Algonquin Park, Ontario. With its 7,700 square kilometres of crystal lakes, rugged cliffs, beaver ponds, spruce bogs and maple forests, Algonquin Park is a canoeist's paradise. There are 1,600 kilometres of established canoe routes through the park's 1,000 lakes, and the park has 45 species of mammals, 262 species of birds and 50 species of fish.

Upper Canada Village, Ontario. Reflecting 1860s community life in Ontario, this 66-acre living museum is without equal in Canada and one of the finest authentically recreated villages in North America. It has fully operational farms and mills, trade workshops, beautiful homes—entirely furnished—and a busy domestic life.

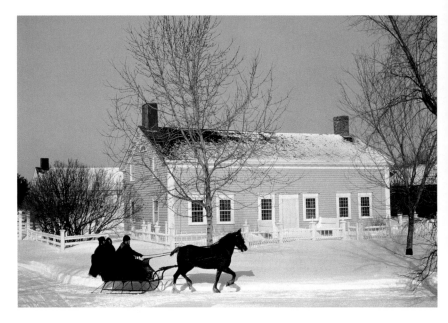

"The Sleeping Giant", Lake Superior, Ontario. The Sleeping Giant is a series of flat-topped mountains, called mesas, that form the hulking silhouette of a reclining giant. This mass of land is at the mouth of the opening to Lake Superior at Thunder Bay.

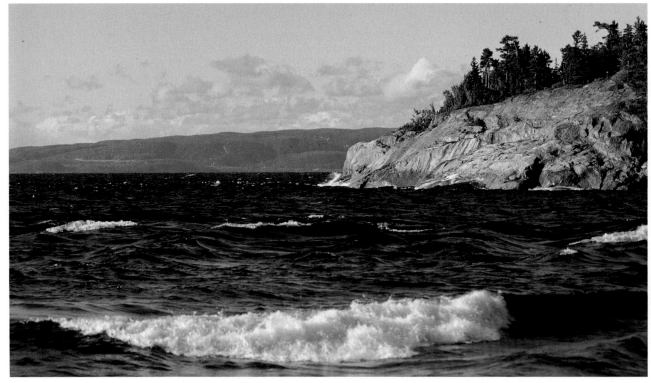

OPPOSITE *Winter Lake Superior, Ontario. Lake Superior, the largest, deepest, and coldest of the five Great Lakes, was created before the ice age by a fault in the underlying rock. It was gradually filled by water from the melting of the glaciers. Lake Superior, the largest body of fresh water in the world, was discovered in 1623 by the French explorer "tienne Brul". In its basin of 91,000 square miles, the lake is fed by more than 200 rivers, almost all of which are very swift and interrupted by rocks and rapids. Even in the summer,the lake temperature does not rise far above freezing point, although the lake never freezes over. In autumn, the lake is subject to violent gales. The north shore is indented with deep bays surrounded by high cliffs; the south shore is, in general, low and sandy.*

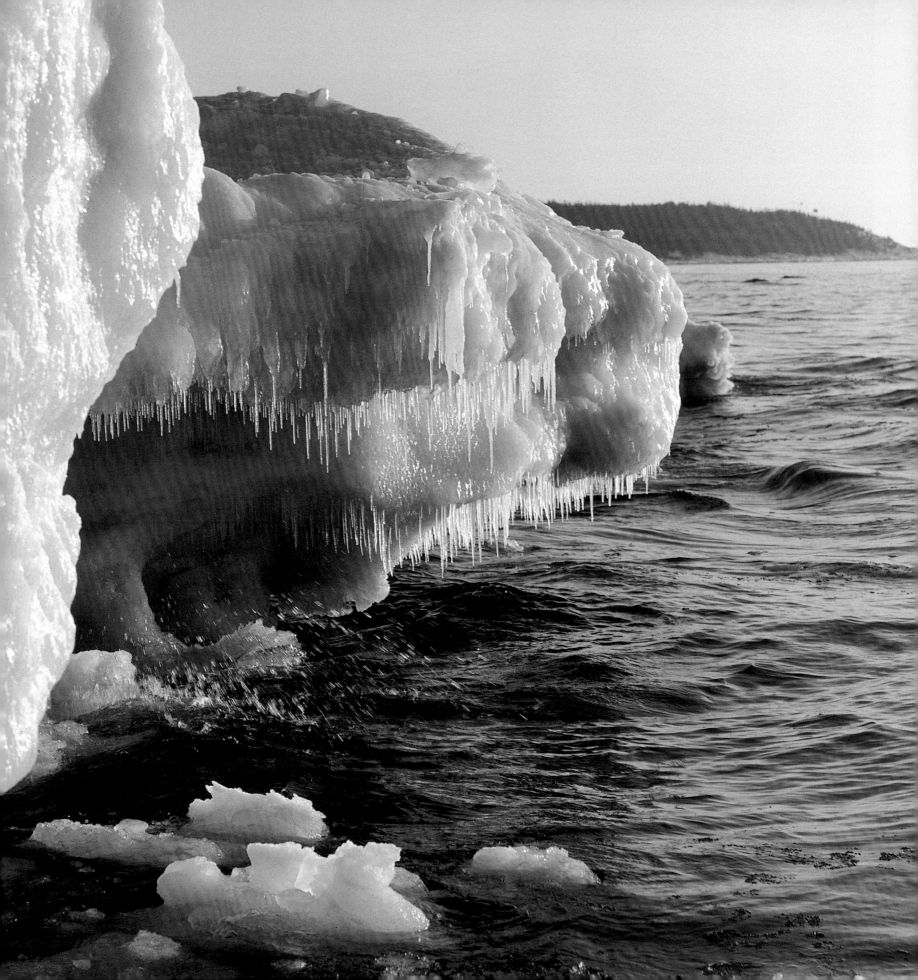

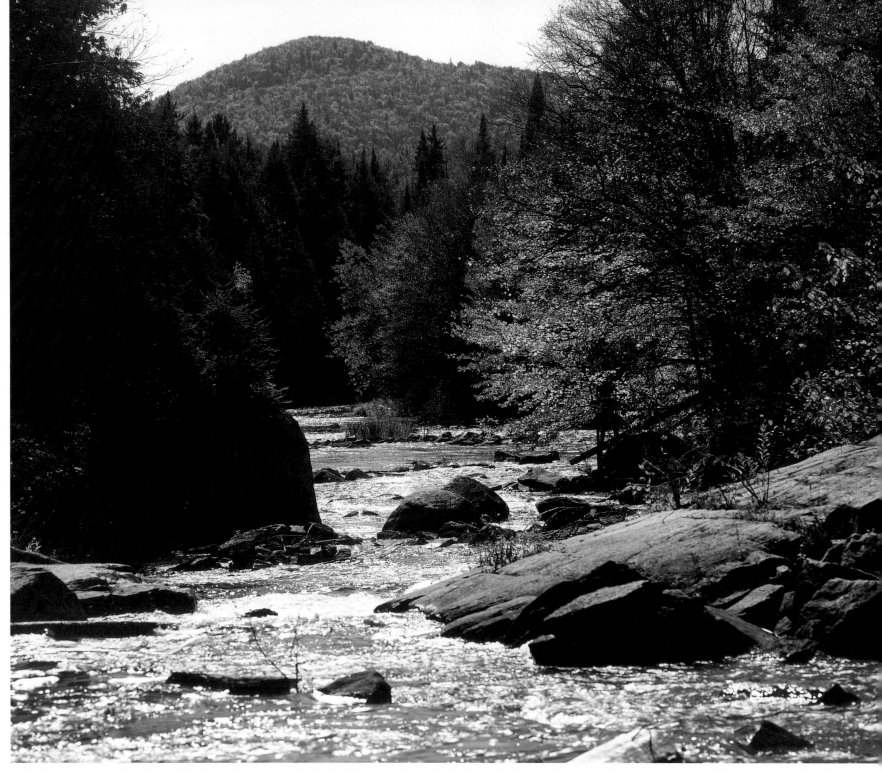

Diable River, Mont Tremblant Park, Québec. The Diable (Devil's) River/Rivière du Diable lies within the Diable watershed, one of the three watersheds in Mont Tremblant Park. A trail following the Diable River leads to a 25-foot-high cascade that gushes through a narrow gorge. The park area was set aside as a forest reserve in 1895 and officially designated as a provincial park in 1981. Maple, beech, birch and evergreens transform the forests into outrageously beautiful scenes in the autumn.

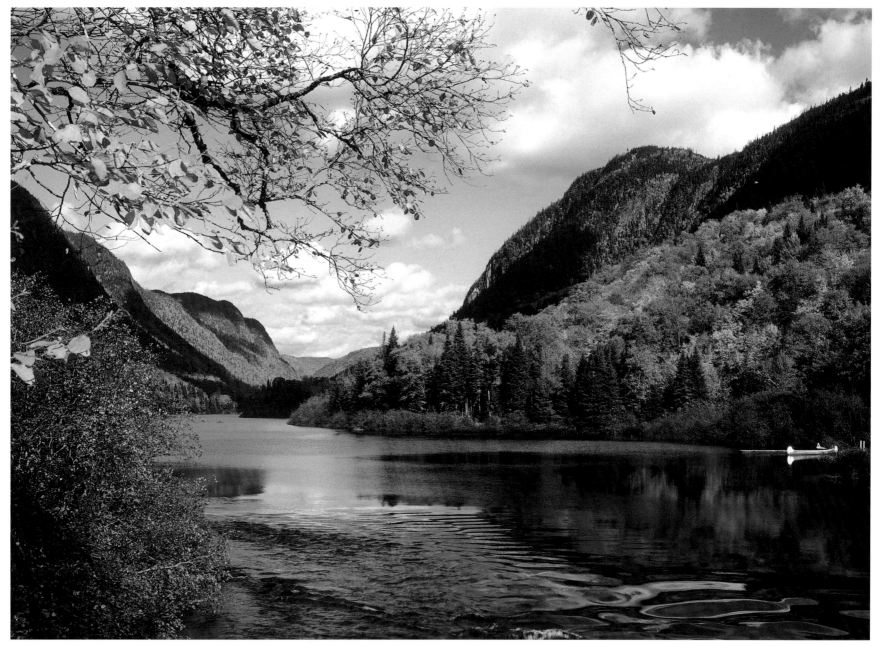

Rivière Jacques Cartier, Québec. The 177-kilometre-long Jacques Cartier River is located in south-central Québec. The river is protected for most of its length by Jacques Cartier Provincial Park in the north and by other publicly owned lands to the south (77% of the shoreline is publicly owned). Most of the river (128 kilometres) has been nominated to the Canadian Heritage Rivers System for its outstanding beauty, its enormous recreational potential and its heritage value in representing the natural and historical evolution of Québec.

*St. Adèle, Québec. St. Adèle was
originally named Morinville
around 1846 by its founder,
Augustin Norbert Morin, but
renamed by him to honour his
wife, Adèle Raymond. Only forty
miles from Montreal, and famous
for its scenic beauty and its skiing
facilities, this all-season resort
community nestles around a small
lake and is equally popular with
artists, writers and sport enthusi-
asts. It also contains the Séraphin
Village Museum, with twenty
buildings recreating the life of the
first settlers of the region.*

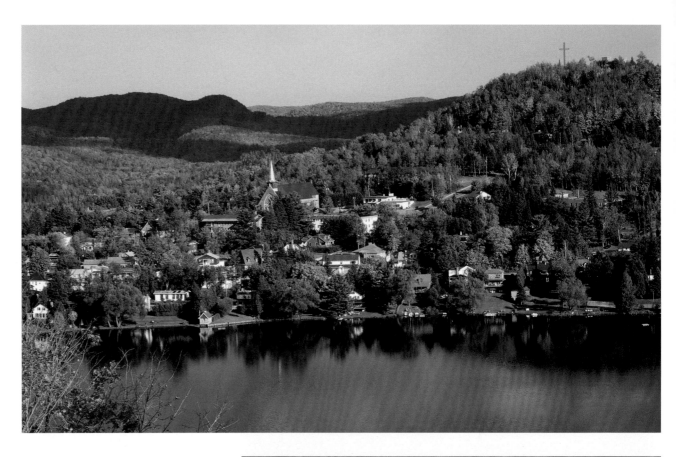

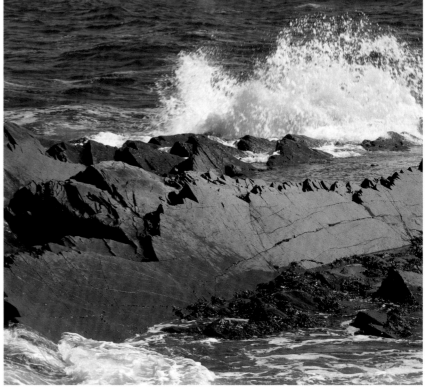

*St. Lawrence River, Gaspé, Québec. Eenroute to the Gulf of St. Lawrence,
the St. Lawrence River passes the Gaspé Peninsula to the south of the river,
flowing by tiny fishing valleys dotting the wild and rocky northern coast of
the peninsula.*

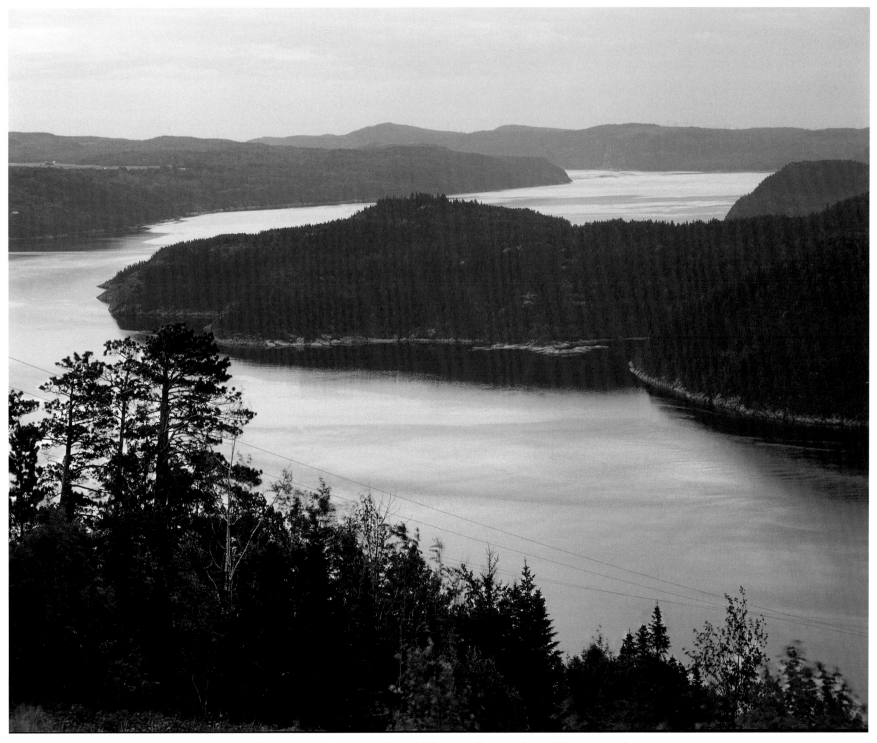

Fjord at Saguenay, near Anse de Rochers, Québec. The Saguenay Fjord, 105 kilometres long and 263 kilometres wide, is a vast flooded valley with a vertical relief of nearly 600 metres where cliffs soar to heights of up to 35 metres and the icy water plunges to a depth of 275 metres. Lofty viewpoints joined by a network of trails make this a favourite destination for hikers and backpackers.

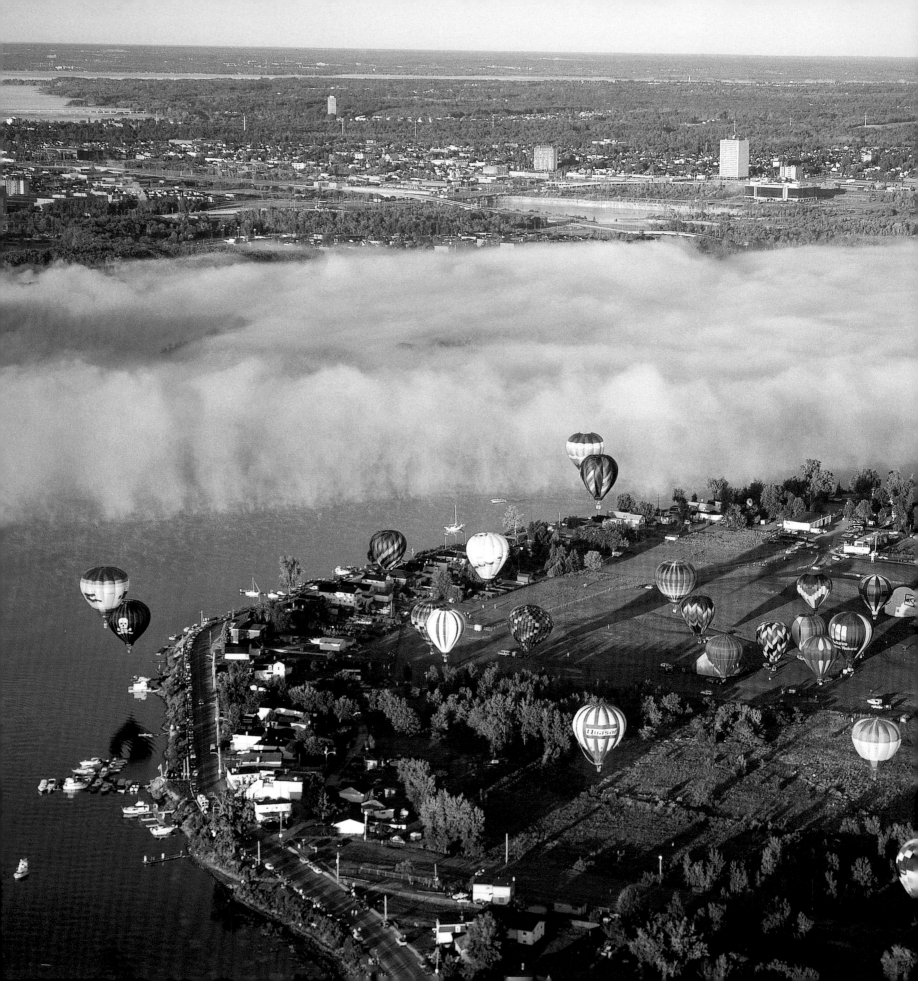

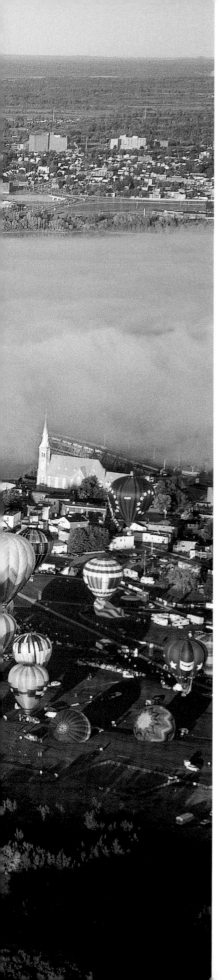

Festival de montgolfières de Gatineau, Québec. The Gatineau Hot Air Balloon Festival has been an annual event since 1987. Attracting balloonists from all parts of the world, this four-day event commences on the last weekend in August and creates a coloured sky in the nation's capital region.

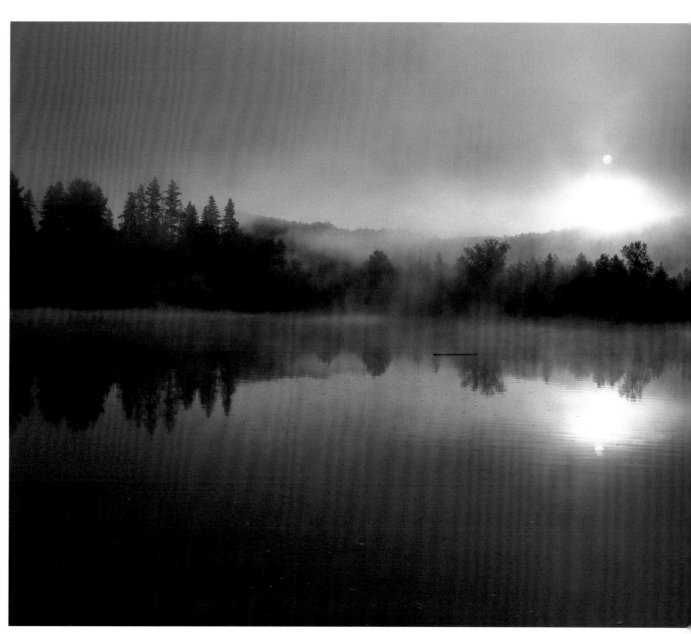

Sunrise on the Gatineau River, Québec. The name of the Gatineau River recalls the seventeenth-century fur trader Nicolas Gatineau, who traded on the river between Ottawa and St. Maurice, and his sons, Louis and Jean-Baptiste, who had trading posts at the mouth of the river.

Steam train, Hull to Wakefield, Québec. In 1992, the Hull-Chelsea-Wakefield train fulfilled a dream—a steam-powered train once more chugging along beside the scenic Gatineau River from Hull to Wakefield from the awakening of spring to the magnificent beauty of autumn (from tulip time to Thanksgiving).

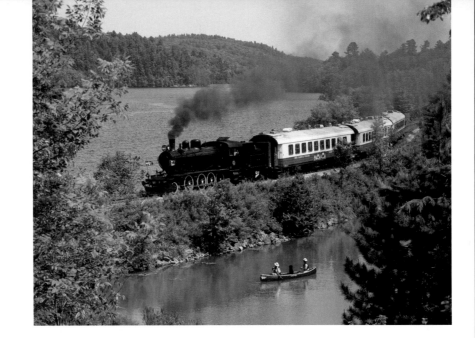

After the ice storm of 1998, along Gatineau Parkway. The ice storm of 1998 had a serious effect on parts of southeastern Ontario and southwestern Québec. Trees were badly damaged—some even uprooted—hydro poles were broken or damaged, power lines were broken, and communication and heating services to homes and businesses were disrupted, with some disruptions lasting for weeks, particularly in the more remote parts of the areas affected. The maple sugar bushes, for example, have yet to recover.

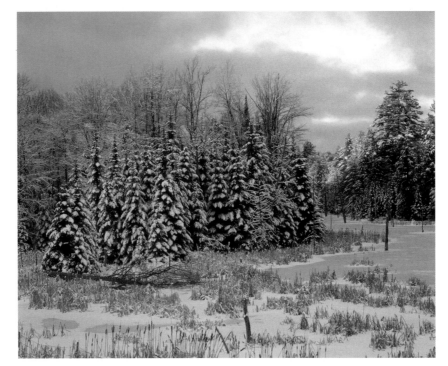

OPPOSITE *Montmorency Falls, with fireworks, Québec. Before emptying into the St. Lawrence River at Québec, Montmorency River cascades over a cliff in a spectacular waterfall (at eight-three metres, it is thirty metres higher than Niagara Falls). In winter, the spray creates a great river of ice that sometimes exceeds thirty metres in height. In season, fireworks make the falls even more spectacular.*

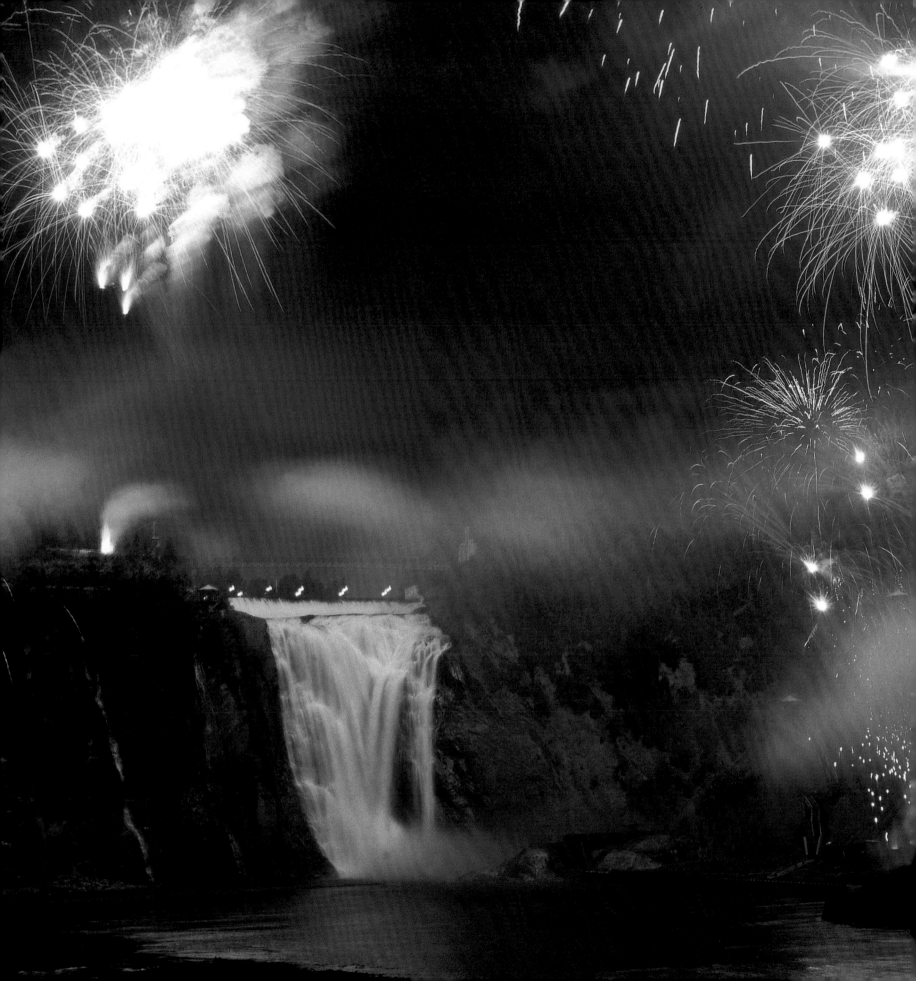

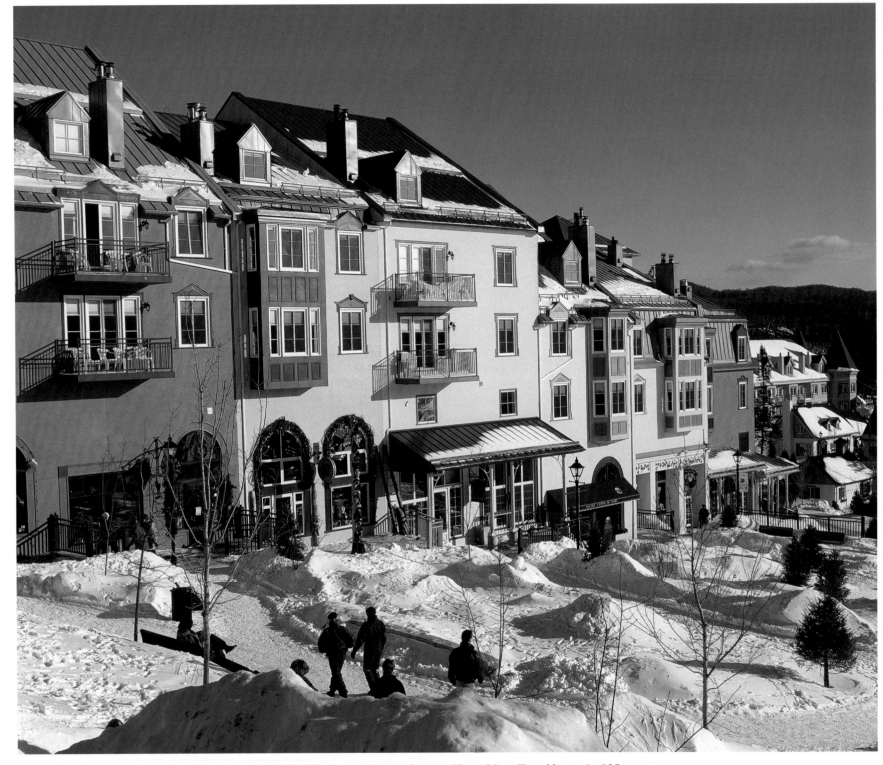

Mont Tremblant, Québec. Mont Tremblant Ski Hill Village is an integral part of Parc Mont Tremblant. At 935 metres, Mont Tremblant itself is the highest peak in the vast Laurentian Highlands, where the landscape is one of rolling, rounded hills and soft peaks, of streams spilling through deep gorges and lakes sprawling through wide valleys.

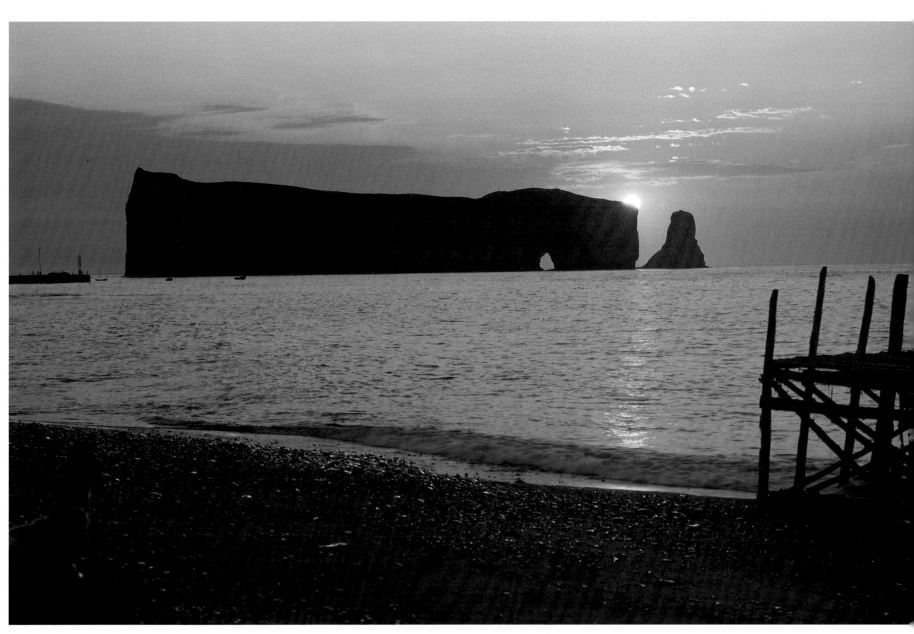

Percé Rock, Gaspé Peninsula, Québec. Percé Rock was noted by Samuel de Champlain in 1603 as a pierced hole, but one of the two arches collapsed in 1845, leaving a detached slab called the L'Obelisque. The sculpted limestone rock is connected to the mainland by a sand bar accessible at low tide.

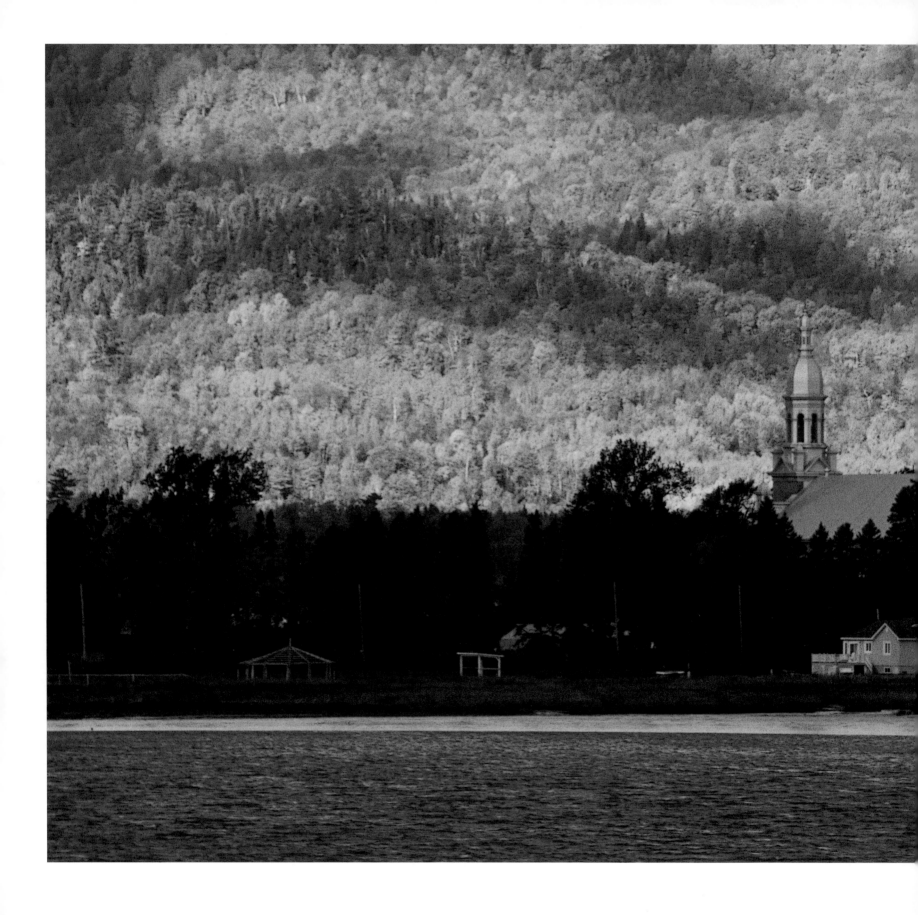

Autumn, Québec. An autumn view of the shore of Québec from the shore of New Brunswick.

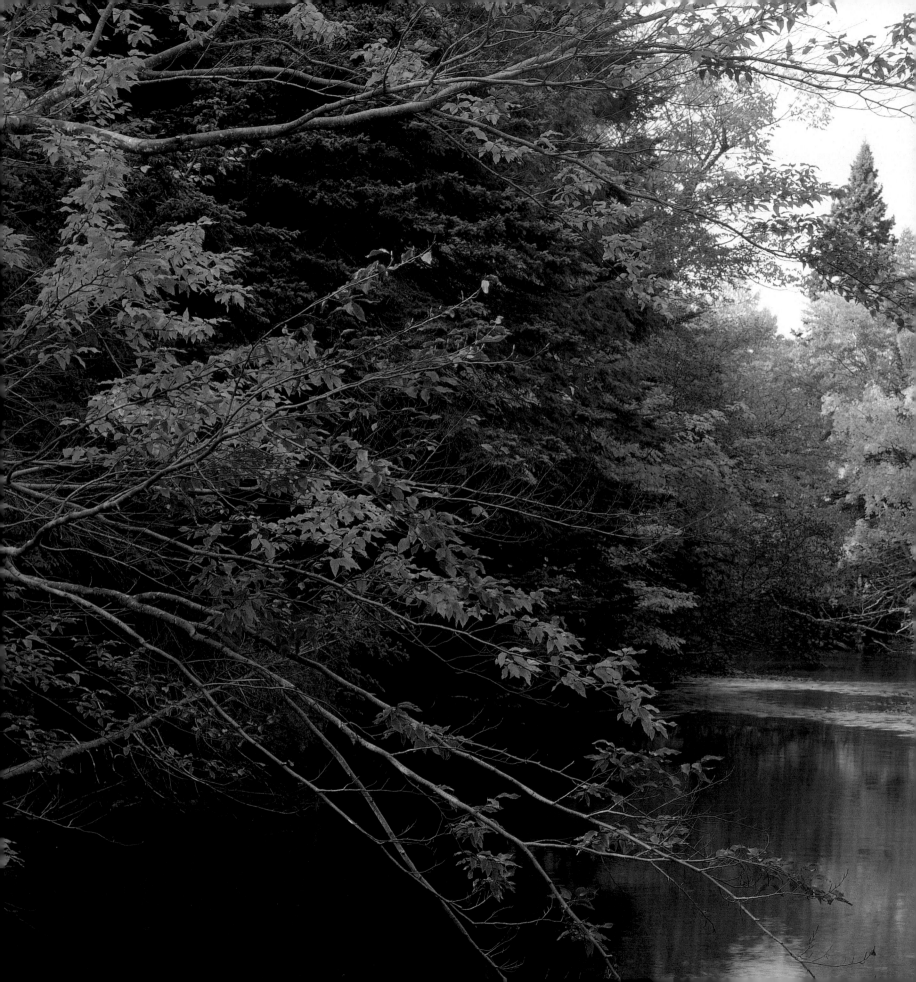

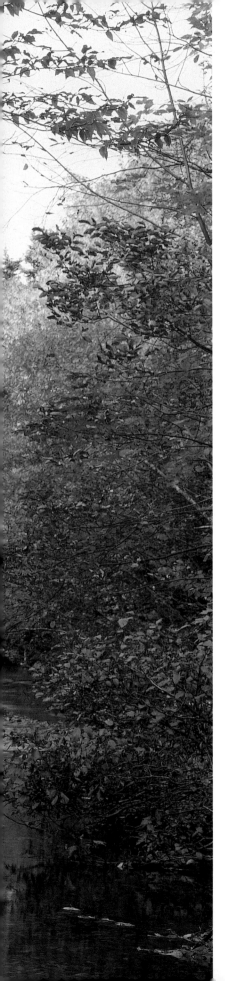

Autumn near Lac Baker, New Brunswick. The smallest incorporated village in New Brunswick, Lac Baker is a quiet, picturesque village located in Baker Lake Provincial Park in northwestern New Brunswick. The lake was named after John Baker, who so strenuously resisted his land's becoming British territory in the 1820s that it inflamed a boundary dispute between New Brunswick and Maine that wasn't resolved until 1842.

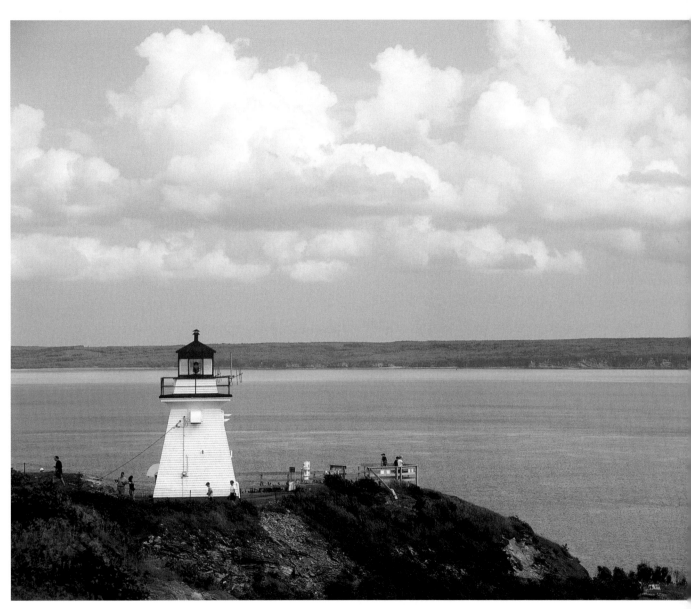

Cape Enrage Lighthouse, New Brunswick. Cape Enrage got its name from local mariners who noticed that when stormy seas passed over the long reef out in front of the cape, it became "enraged," or turbulent. One of the oldest in southeastern New Brunswick, this lighthouse was built in 1840.

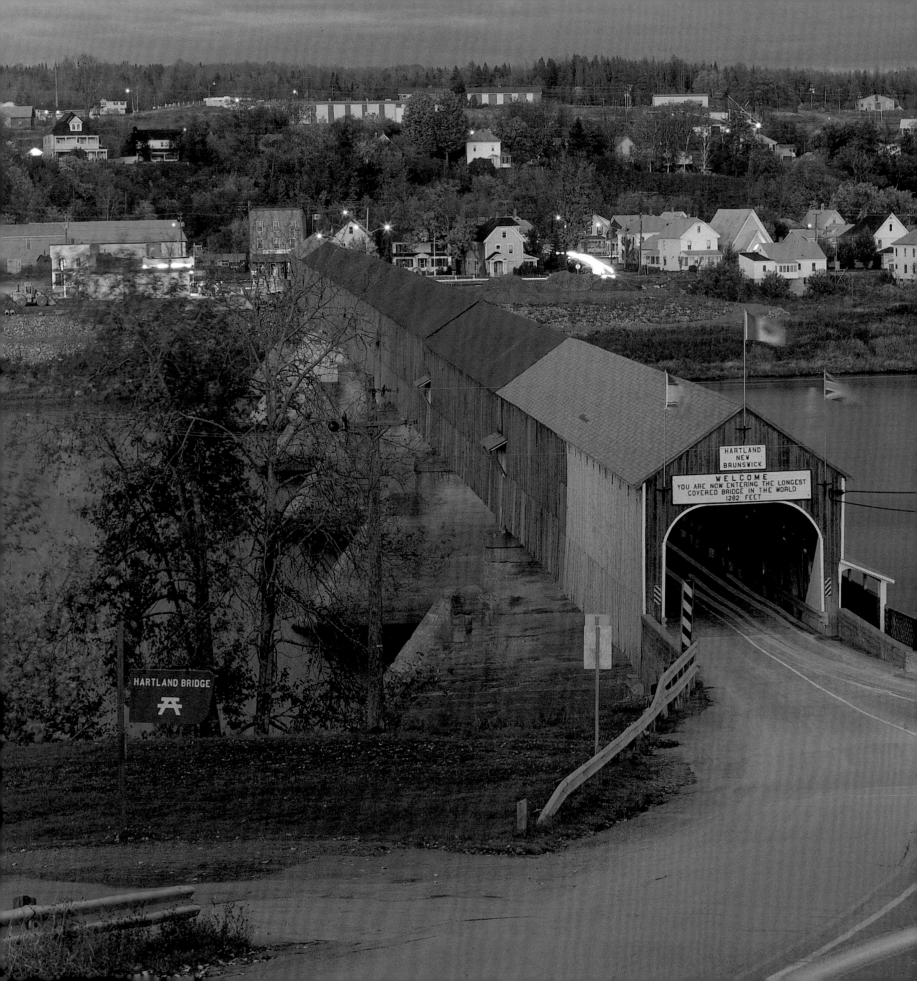

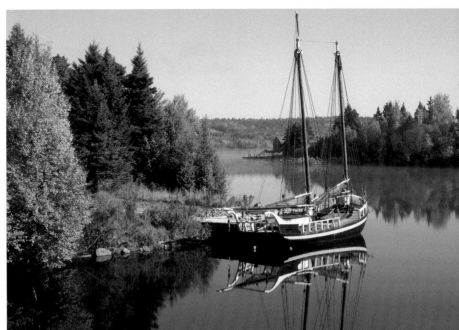

Prince William sailing ship, Kings Landing Historical Settlement, New Brunswick. Located on the banks of the beautiful Saint John River, Kings Landing Historical Settlement recreates life in the nineteenth century. More than a hundred costumed artisans bring to life all the chores, the entertainment and the lifestyle of pioneers to the area in historic homes, farms, mills, churches, a school and a factory. The setting is breathtakingly picturesque.

Hartland Covered Bridge, New Brunswick. At 391 metres, this is the longest covered bridge in the world, crossing the Saint John River in seven spans. Officially opened on July 4 ,1901, and rebuilt in 1920, the Hartland Covered Bridge was declared a national historic site on June 23, 1980.

Hopewell Cape, The Rocks Provincial Park, New Brunswick. These red sandstone flowerpot rocks were carved by melting glaciers, then sculpted by wind, frost and the highest tides in the world. The village offers a picturesque view of the "Chocolate River," a nickname given to the river because of the colour created by the clay-type riverbed base.

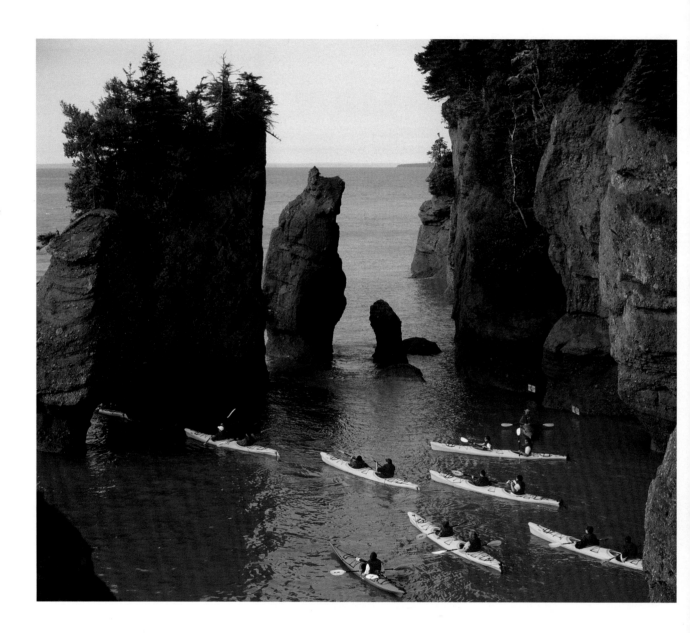

OPPOSITE *Long Reach, Saint John River, New Brunswick. Long Reach, as a broad, straight section near the mouth of the river is called, is where the river strikes off at right angles northeast from Grand Bay. The hills of the Long Reach are covered by virgin forest glorious with colour in the fall.*

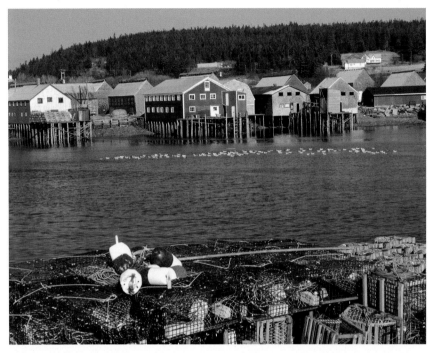

Seal Cove, Grand Manan Island, New Brunswick. A beautiful little fishing village nestled in the hills on the edge of the ocean, this town is the southern-most village on the island. Both the hooded seal and the harp seal have played significant roles in the economic development of the Atlantic Coast as sources of food and clothing.

Early morning mist, New Brunswick

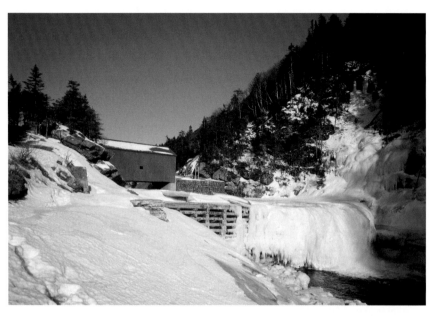

Fundy National Park, New Brunswick. Fundy National Park lies between the Saint John River system and the Petitcodiac River system. In the early days of settlement, the unexploited wilderness was an attractive source of lumber for the rapidly growing city of Saint John, eighty kilometres to the west, and for export to England, the Caribbean islands and New England. Several small communities, populated by immigrants from Scotland, Ireland and England, grew within the existing park boundaries. The park contains steep sea cliffs, rolling parkland sliced by deep-cut rivers and streams in low valleys, and vast tidal flats that can be explored at low tide.

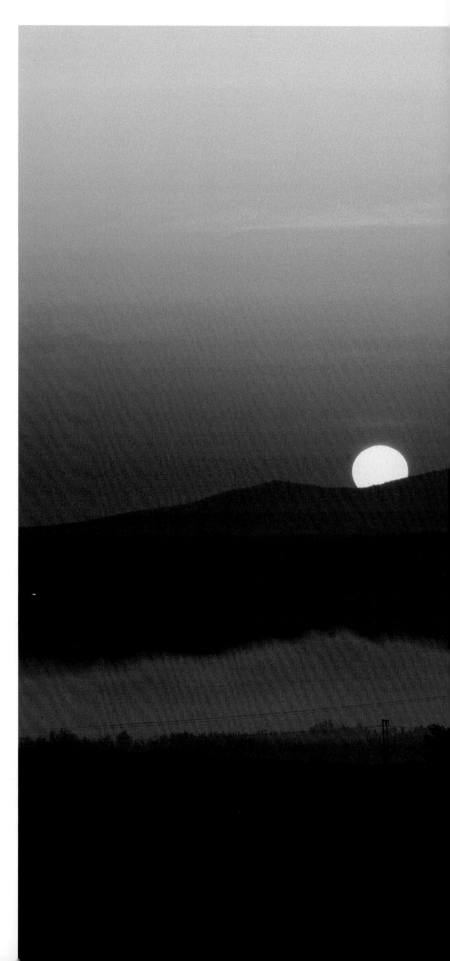

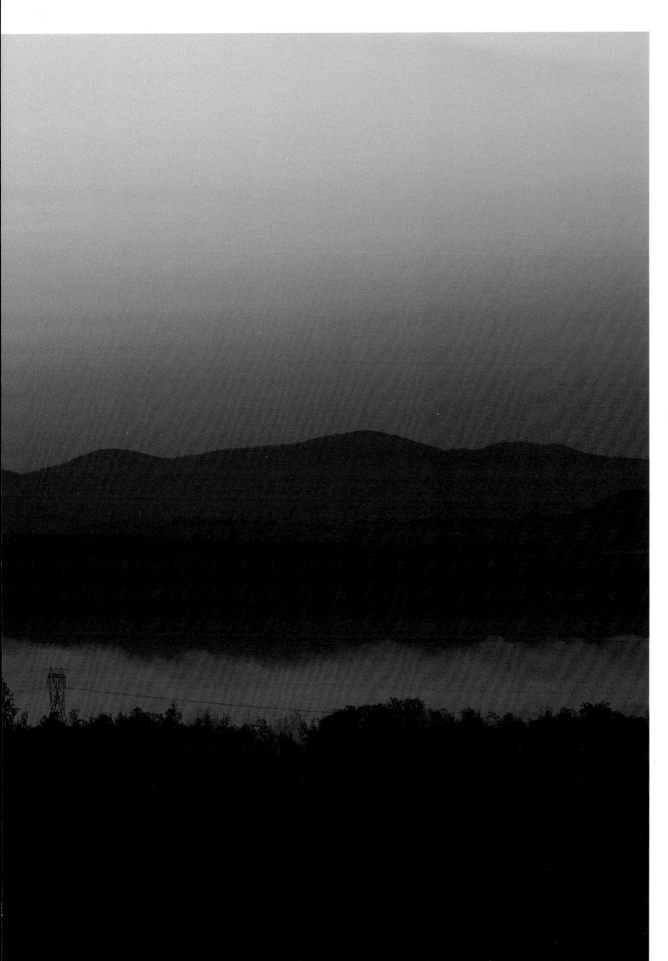

Sunrise over the Saint John River, New Brunswick. The Saint John River, part of the extensive network of rivers in New Brunswick, flows from north to south in the western part of the province and forms part of the border with Maine. Where the force of the incoming tide reverses a series of low waterfalls as the river meets the sea, the river gives rise to the Reversing Falls—the water rushes uphill in a tidal wall against the normal flow of the falls, defying gravity. This tidal activity in the Bay of Fundy also helps keep its ports ice-free in the winter. Several big dams have been constructed on the Saint John River, among them producing enough hydropower to meet a large part of New Brunswick's needs.

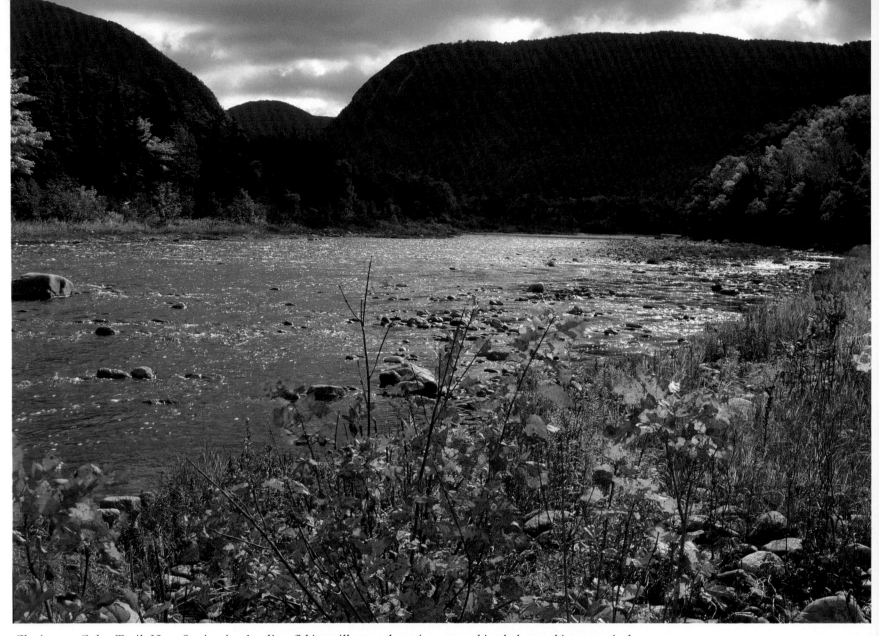

Cheticamp, Cabot Trail, Nova Scotia. An Acadian fishing village and tourist centre, this whale-watching town is the western entrance to Cape Breton Highlands National Park. A protected harbour and a large stone church dedicated to St. Peter distinguish the town. The name Cheticamp is a hybrid from the Micmac and French. The first Acadians interpreted the name as Chetif Camp, meaning "Poor camping ground."

OPPOSITE *Cabot Trail, Cape Breton Island, Nova Scotia. This trail, now a paved highway, has become known as one of the world's finest scenic tours, set apart from others with spectacular scenery, abundant wildlife and a human history that stretches back to the last Ice Age. Some areas along the trail are reminiscent of the Scottish Highlands, ancestral home of many of the island's inhabitants. The East Coast is especially rich in Gaelic culture, derived from the language of the Celts in Ireland and the Scots in Scotland.*

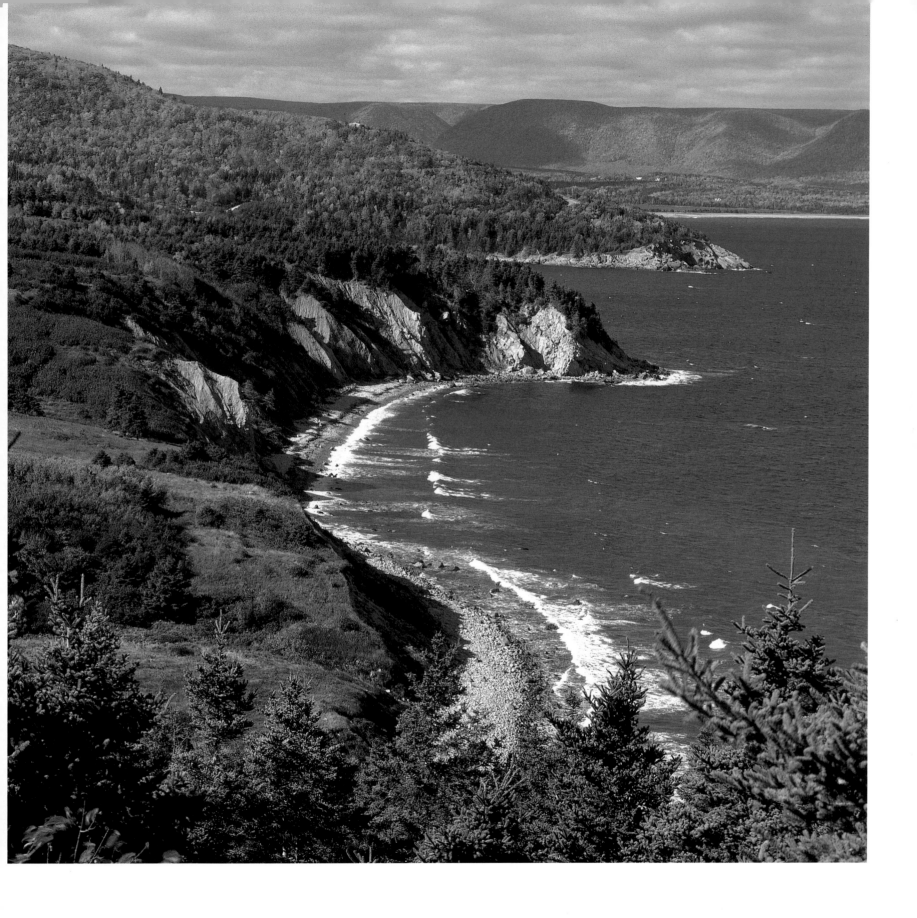

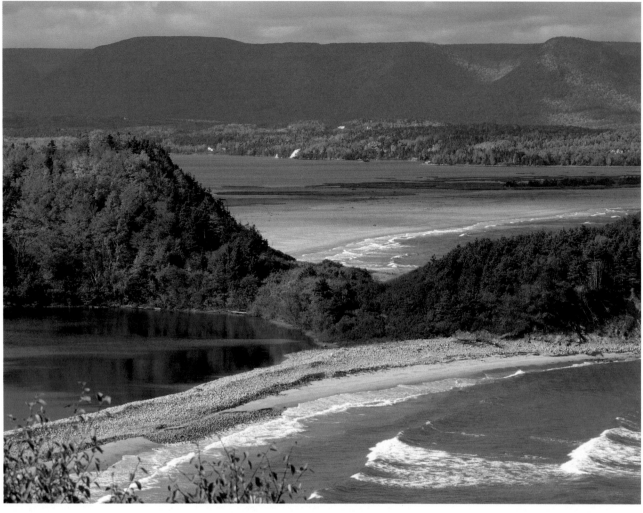

Aspy Bay, Cape Breton Island, Nova Scotia. Aspy Bay, on the northeast side of Cape Breton Island, is anchored by the bordering hills and surrounded by beach, and faces the north Atlantic. Its name, with its roots in the Micmac language, means "end place."

OPPOSITE *Peggy's Cove Lighthouse, Nova Scotia. Peggy's Cove is a small, picturesque fishing village (population 120) that surrounds a narrow ocean inlet. A lighthouse built on the large, smooth, wave-washed granite rocks is the crowning feature of this beautiful Atlantic cove.*

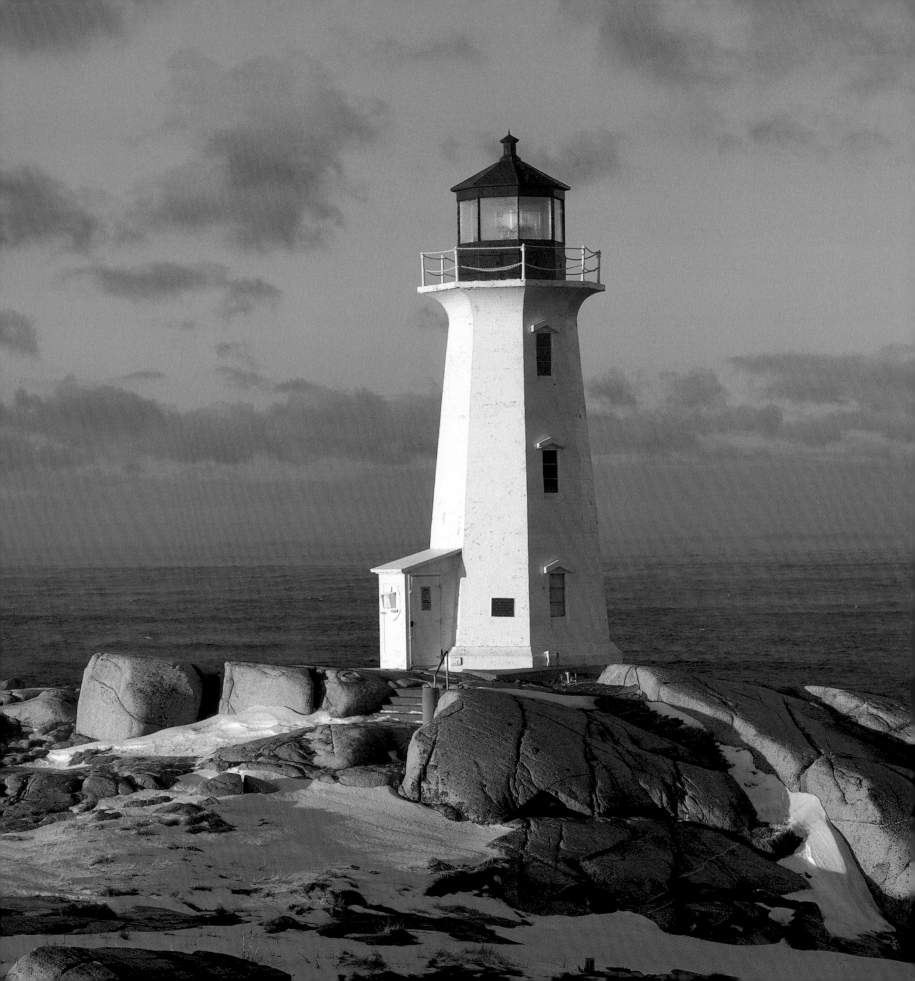

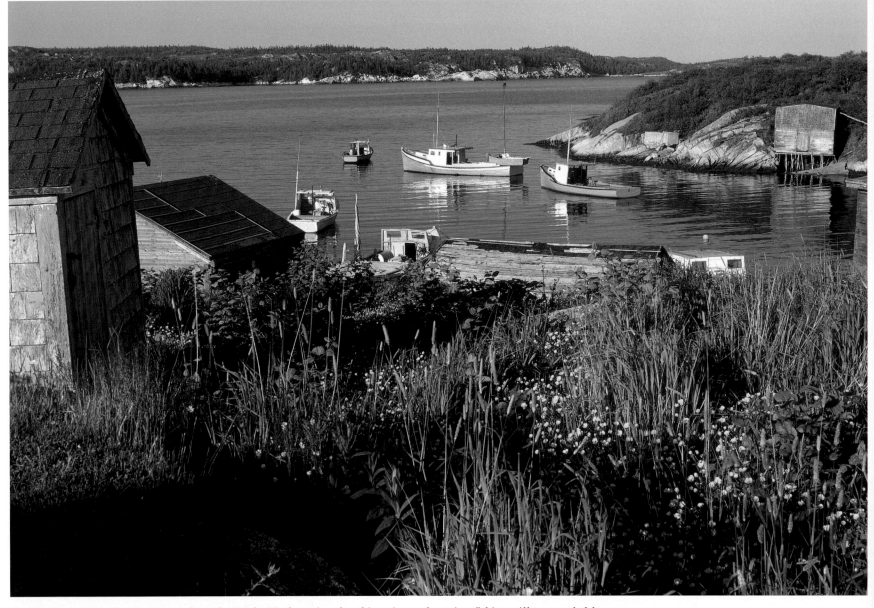

Sandy Cove, Nova Scotia. Located on the Digby Neck peninsula, this quiet and quaint fishing village nestled between two coves is home to whale watching, beachcombing, bird watching and one of Nova Scotia's highest waterfalls.

OPPOSITE *Peggy's Cove, Nova Scotia. Known as a calm fishing village, Peggy's Cove is one of the most popular stops in Atlantic Canada. Set on rocky shores, the lighthouse and village at Peggy's Cove are a paradise for photographers and artists. Despite its popularity, this tiny fishing village has been able to keep the relaxed atmosphere that has made it famous.*

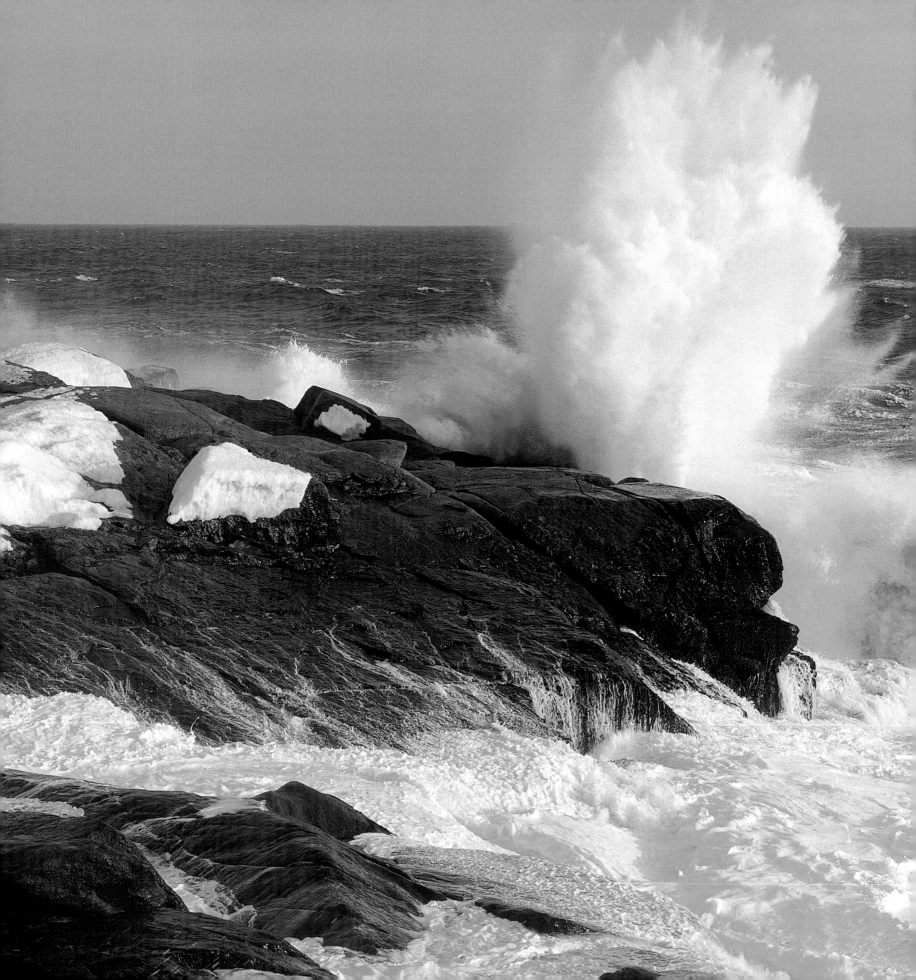

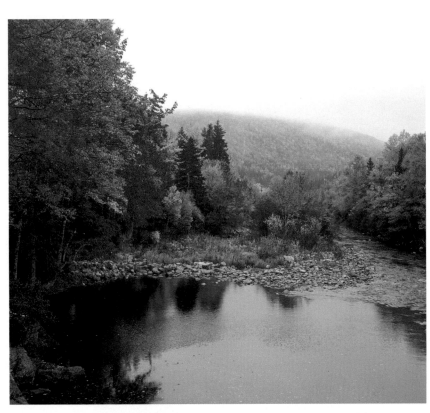

Cape Breton Highlands National Park, Nova Scotia. Home to the famous Cabot Trail and one of the Maritimes' most beautiful areas, the park is located at the eastern edge of Nova Scotia. The park sits on a highland that falls off abruptly into the Atlantic Ocean while the headlands and cliffs tower over the rich natural heritage that is all around.

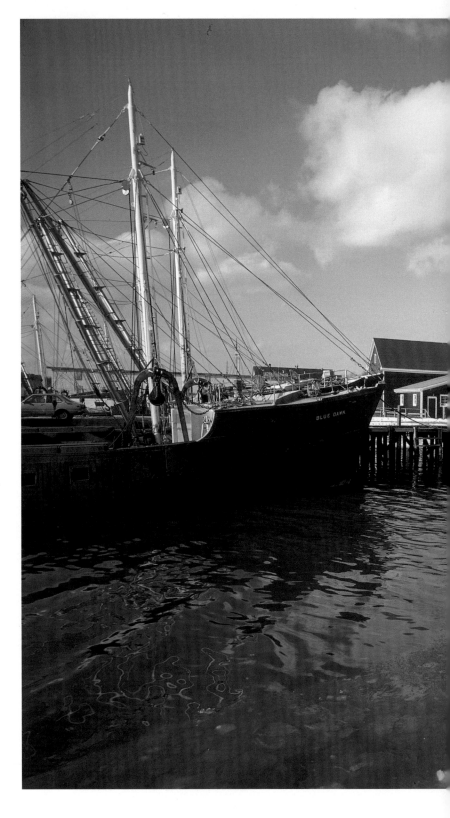

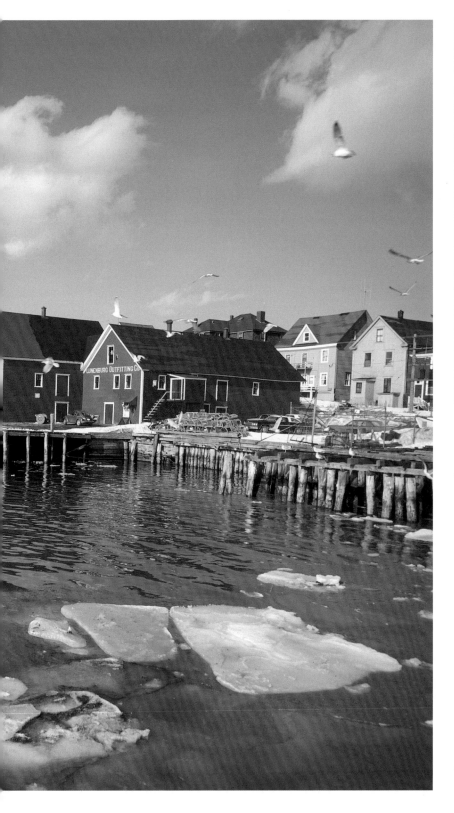

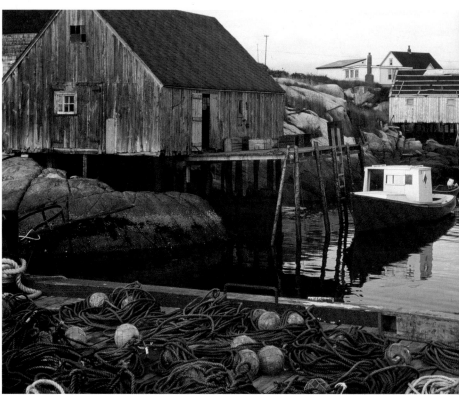

Peggy's Cove, Nova Scotia. The Cove is located on the eastern side of St. Margaret's Bay, a large expanse of water fringed by a number of towns and fishing villages, and has been a fishing village since its founding in 1811. This community is built on the rocky hills that surround the small cove and the extremely narrow channel entrance affords good protection from the wild storms of the North Atlantic.

Lunenburg, Nova Scotia. Home of the Bluenose and a UNESCO World Heritage Site, Lunenburg and the nearby seaside community of Blue Rocks are classic examples of the area's vivid beauty, making it an inspiring location for artists. The town, founded in 1888, takes its name from the British royal house of Brunswick-Lunenburg.

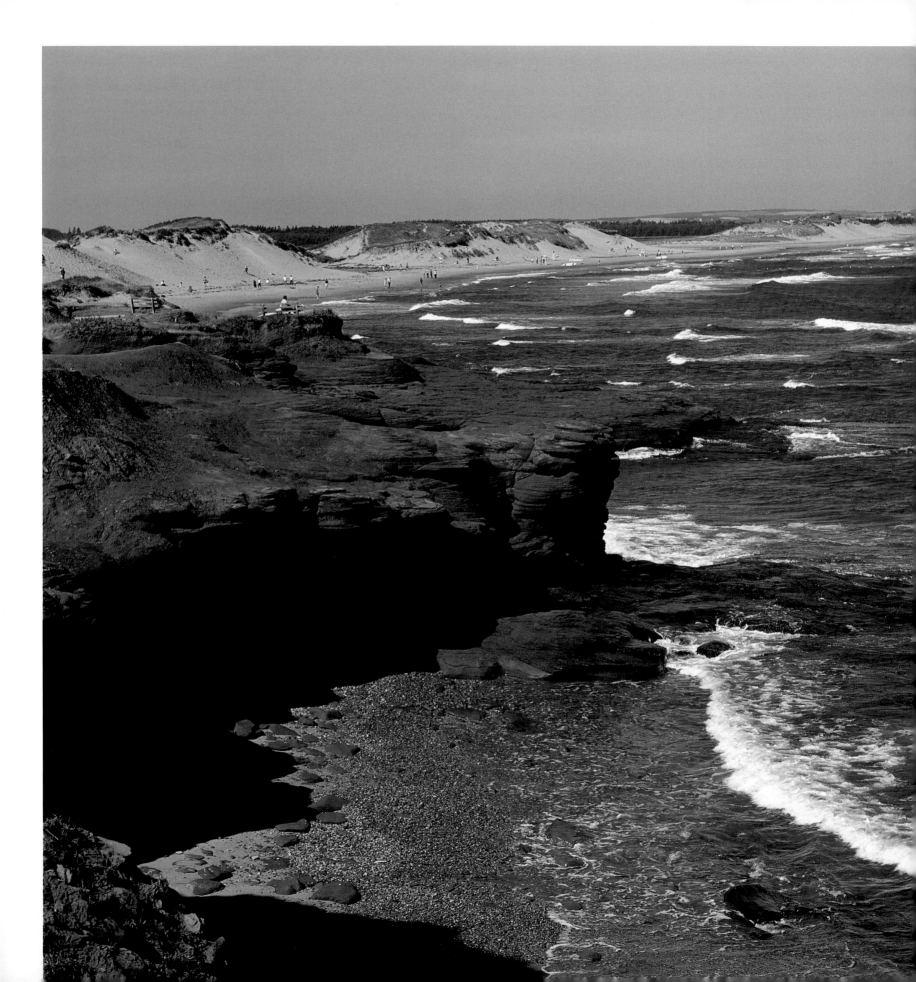

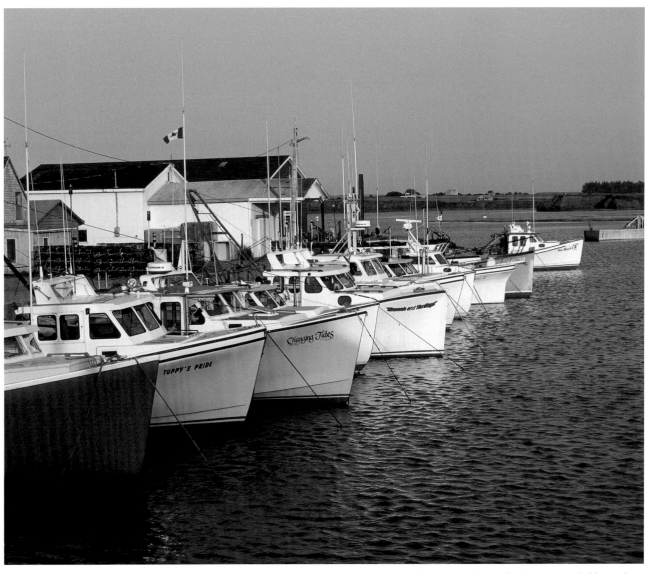

Malpeque Cove Harbour, P.E.I. "Malpeque oysters" have long been recognized nationwide as the finest available to the connoisseur. Malpeque was once a large shipbuilding town and its Kier Memorial Museum has a wealth of artefacts and history on the area. A unique feature of this part of the coast are the long, narrow sand dune islands that shelter the entrance of Malpeque Bay.

Cavendish Beach, P.E.I. This beach is surrounded by the warmest waters north of Virginia, rolling dunes and peaceful sunsets, which have made Prince Edward Island's beaches world-famous.

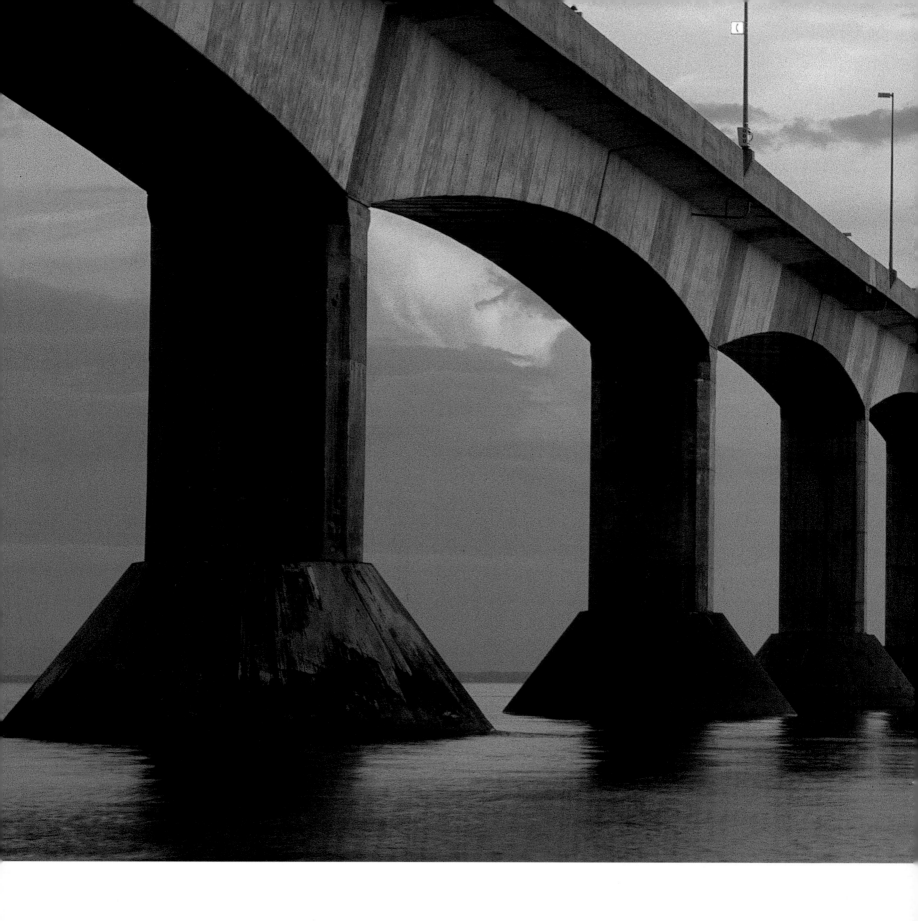

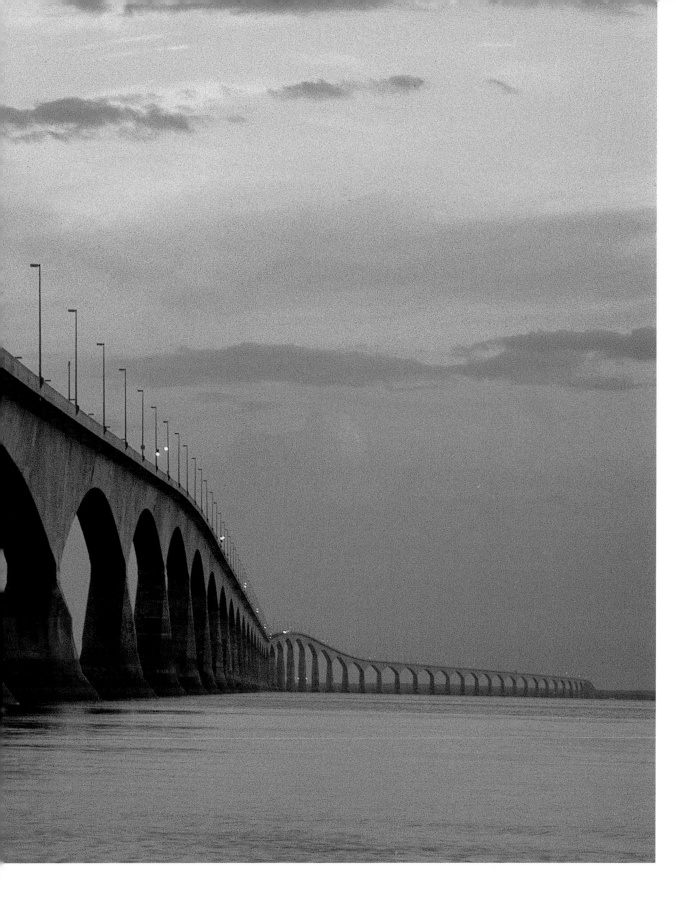

Confederation Bridge, Borden-Carleton, P.E.I. Opened in May 1997, the 12.9-kilometre Confederation Bridge joins Borden-Carleton, Prince Edward Island, and Cape Jourimain, New Brunswick. With the Northumberland Strait freezing for three to four months of the year, it is the longest bridge over ice-covered waters in the world.

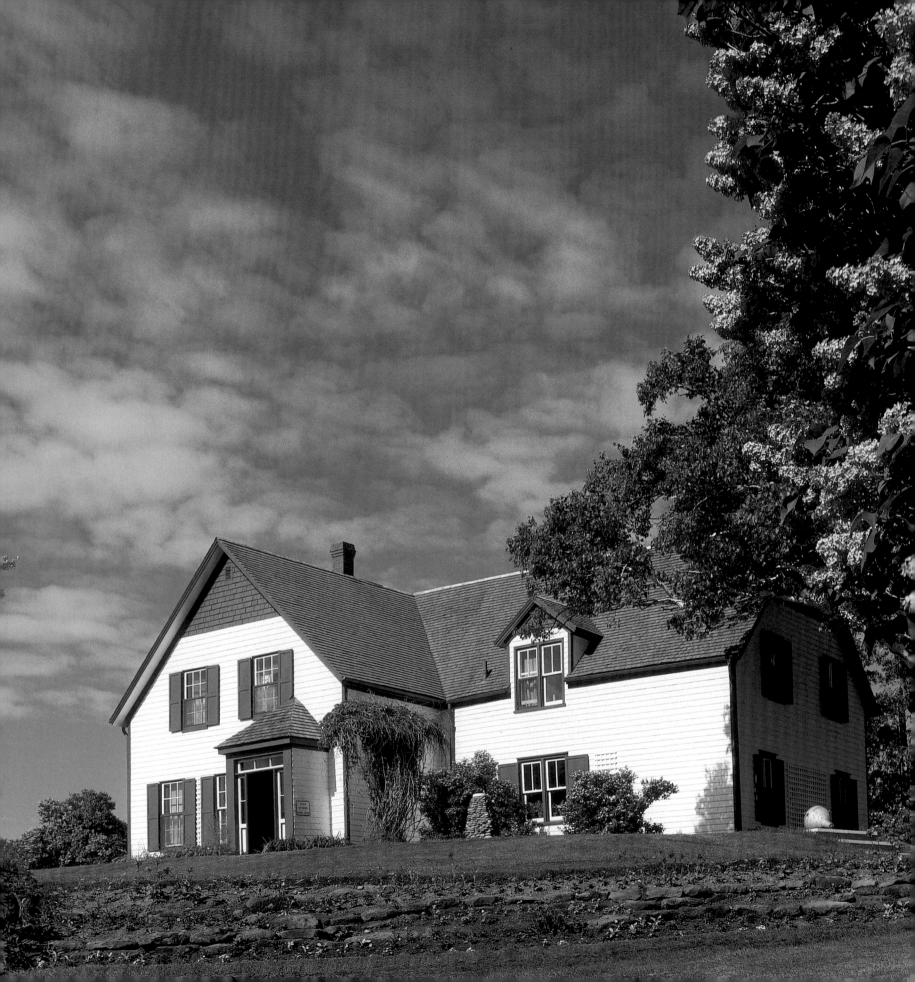

Green Gables House, Cavendish, P.E.I., Prince Edward Island National Park. In 1937, Green Gables was recognized for its significance to the writings of Lucy Maud Montgomery, purchased by the federal government and joined with the Prince Edward Island National Park system. The home has been restored and furnished with period artefacts, and to mark the site, a national historic site monument has been erected in honour of L.M. Montgomery's works. The Anne of Green Gables story has become popular in 18 languages and draws summer visitors from the world over.

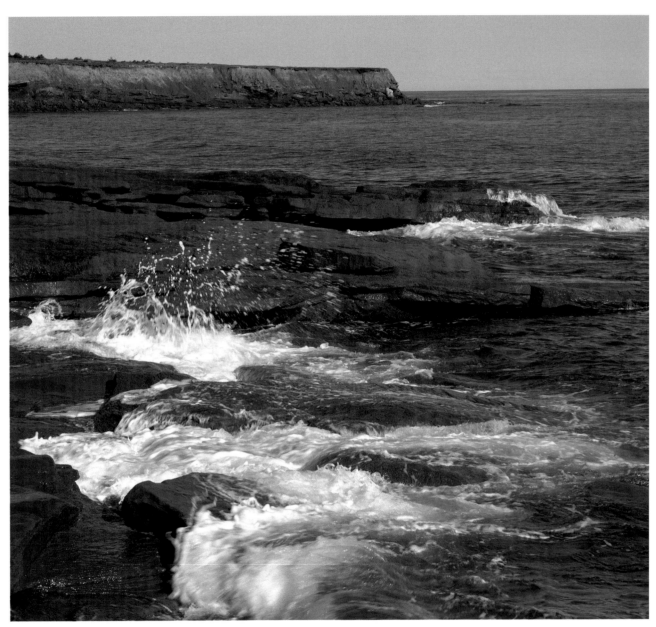

Cape Tryon, P.E.I. Hidden by the wave-cut base of the overhanging escarpment, the ledges, shaped from horizontally layered levels, provide an ideal site for the largest cormorant colony in the province, the white excrement draping the rock like snow-dusted peaks.

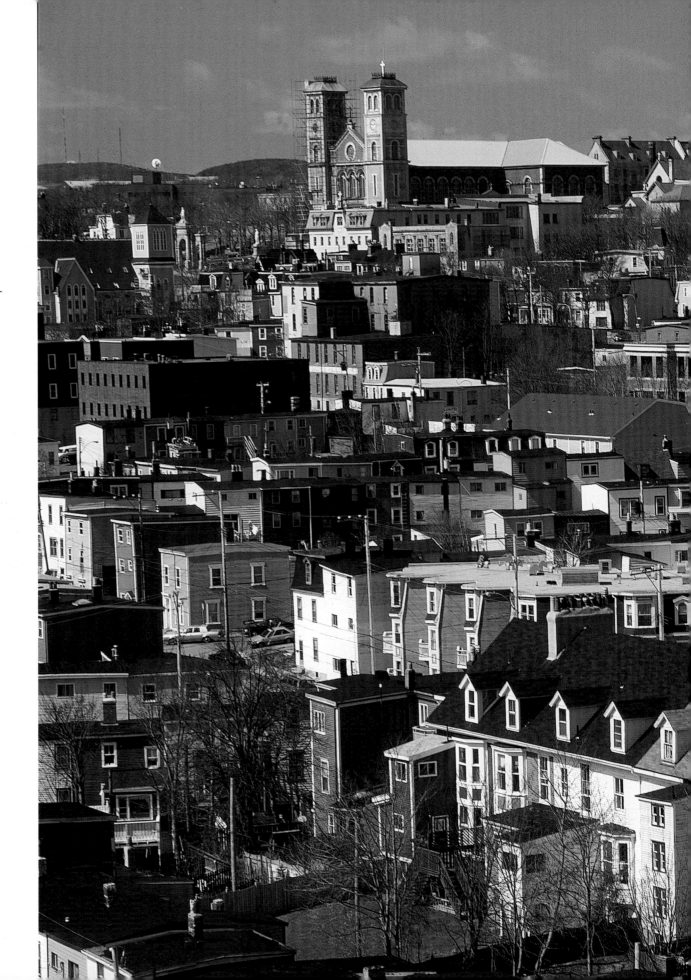

*St. John's, Newfoundland.
Arriving in St. John's Harbour in
1583, Sir Humphrey Gilbert
declared Her Majesty's sovereignty,
thus giving England its first posses-
sion in the New World. Though
three major fires ravaged the com-
mercial and political capital of
Newfoundland in 1816, 1846
and 1892, St. John's recovered
and was able to rebuild after each
one. Today it functions as the
economic, political, cultural,
commercial and financial centre
for Newfoundland and Labrador,
as well as the capital of the
province.*

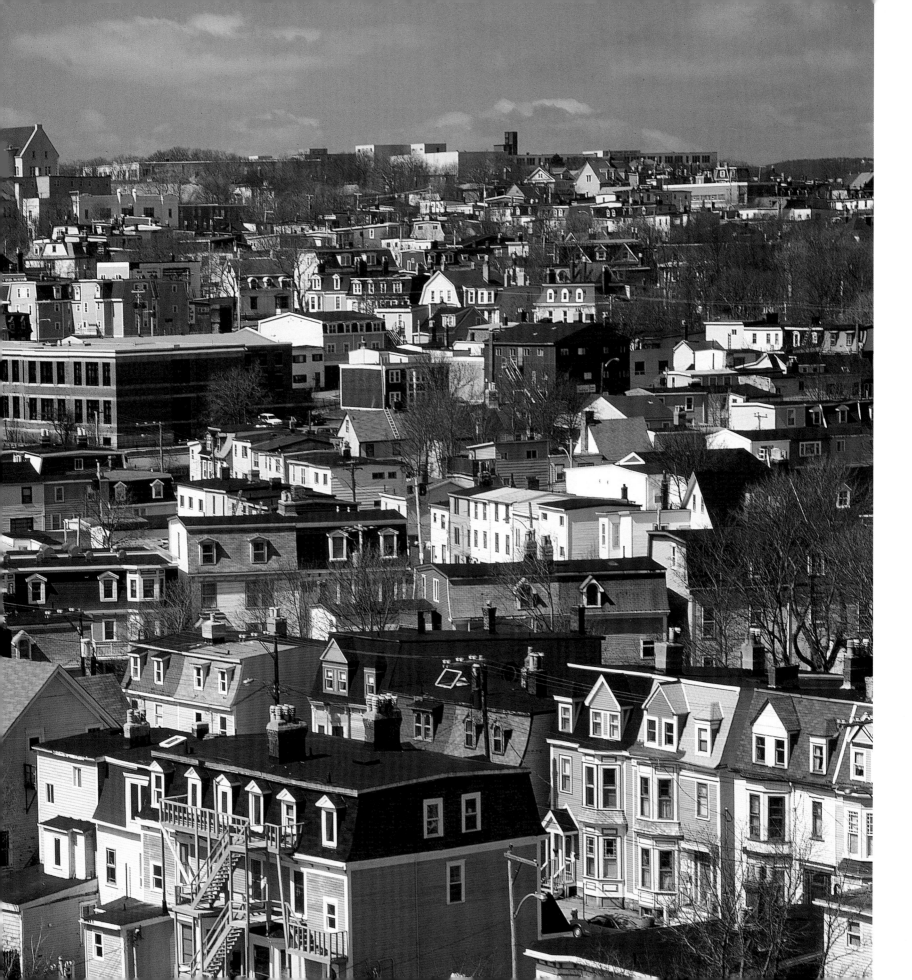

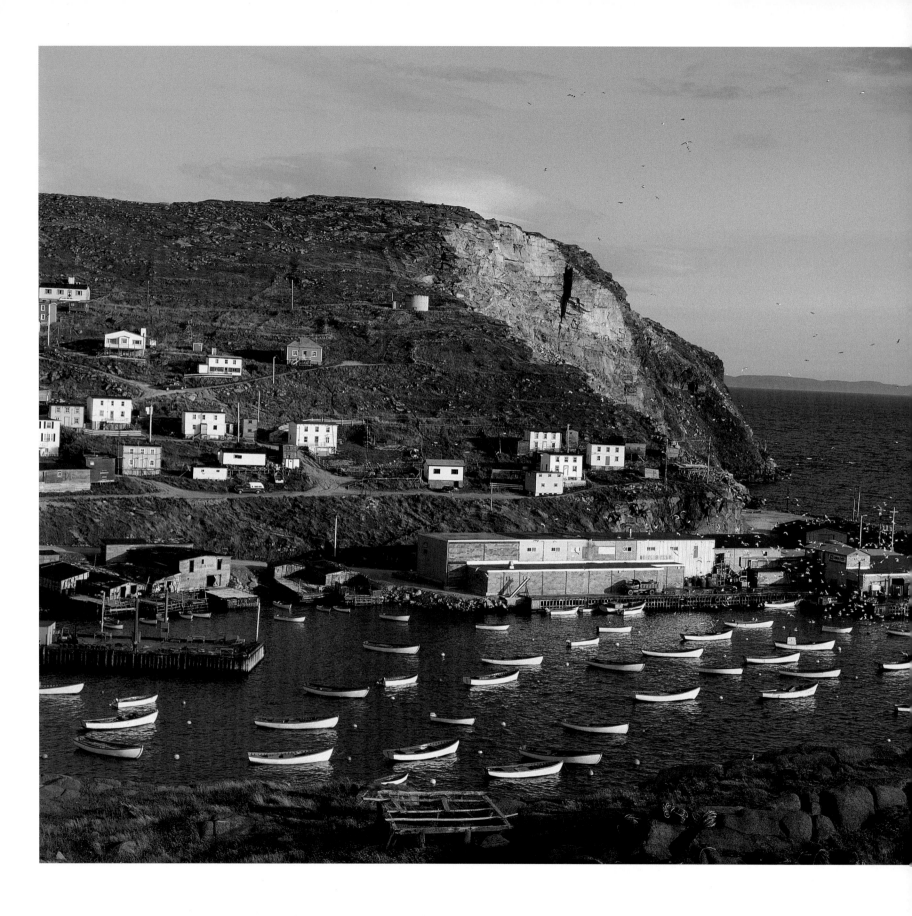

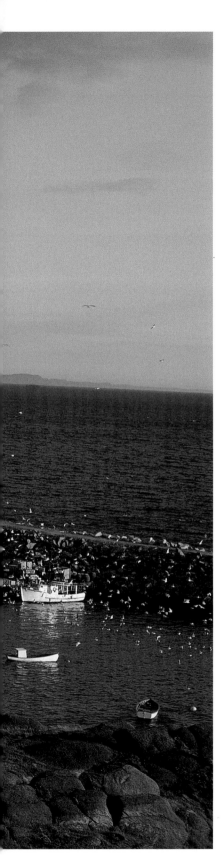

Bay de Verde, Newfoundland. Bay de Verde, with some of the most striking scenery in the province, is located at the top of the peninsula that separates Trinity Bay from Conception Bay. It is situated five kilometres west of the large, well-known sea bird colonies on Baccalieu Island. The name Bay de Verde derives from a combination of the English, Portuguese and French languages. John Guy, one of Newfoundland's first settlers, who visited in 1611, named the community Green Bay because of its appearance in summer.

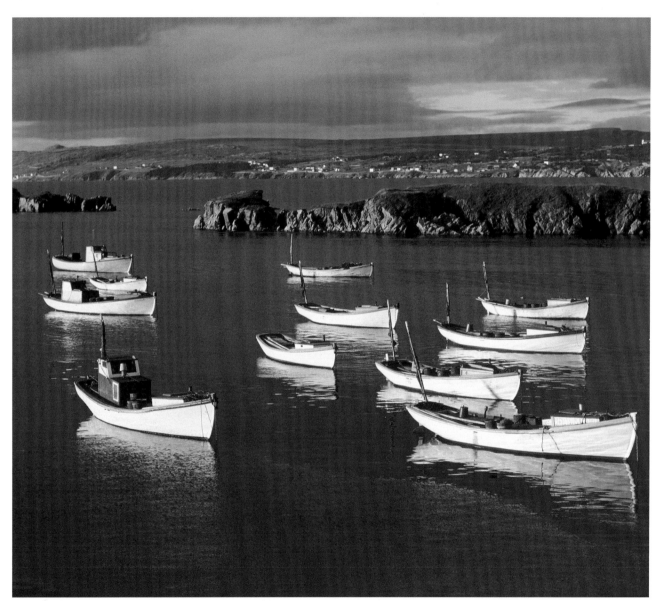

Port de Grave, Newfoundland. In Newfoundland, the small fishing villages are dispersed along the coast in sheltered bays, near headlands or on islands, because when it was first established, each family wanted space for fish-drying flakes, separate wharves and adjoining gardens—all with a shore location. Therefore these fishing villages developed distinct dispersed housing.

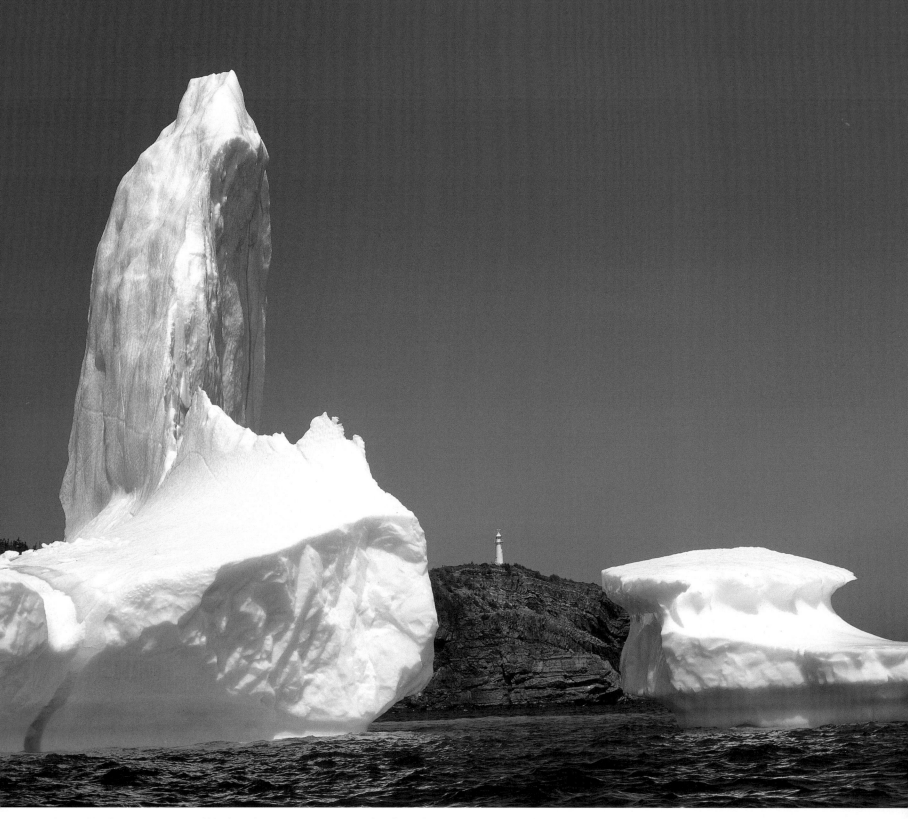

Iceberg, King's Cove, Newfoundland. Icebergs are a common sight along the coast of Newfoundland from March until July. They originate from the glaciers of West Greenland, where 30,000 to 40,000 are calved annually. Carried north around Baffin Bay, they do not appear in Newfoundland waters until their second year at sea.

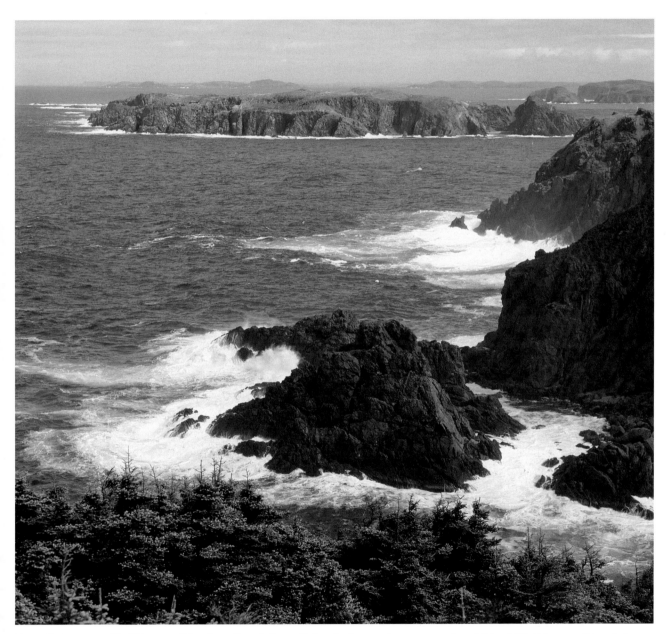

Long Point, near Twillingate, Newfoundland. Long Point is the northern extremity of North Twillingate Island, in Notre Dame Bay. The lighthouse provides a great vantage point for watching whales and icebergs, as it has a superb view of the ocean and the surrounding islands.

OVERLEAF *Gros Morne National Park, Newfoundland. Beyond its awe-inspiring scenic beauty, Gros Morne boasts an incredible biotic richness and is internationally acclaimed for its unique combination of geologic features. The park is dominated by two distinctly different landscapes, a coastal lowland bordering the Gulf of St. Lawrence and the alpine highland of the Long Range Mountains. Gros Morne National Park offers some of the best unspoiled wilderness hiking and backpacking opportunities in eastern North America.*

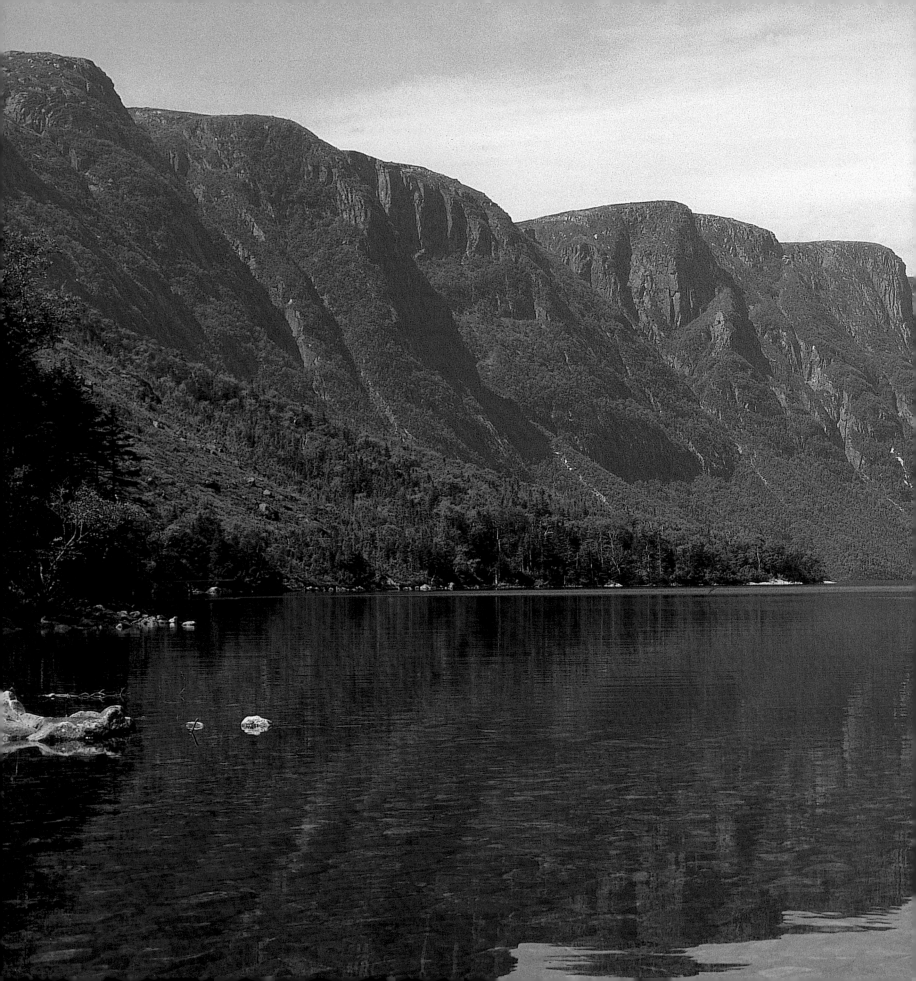

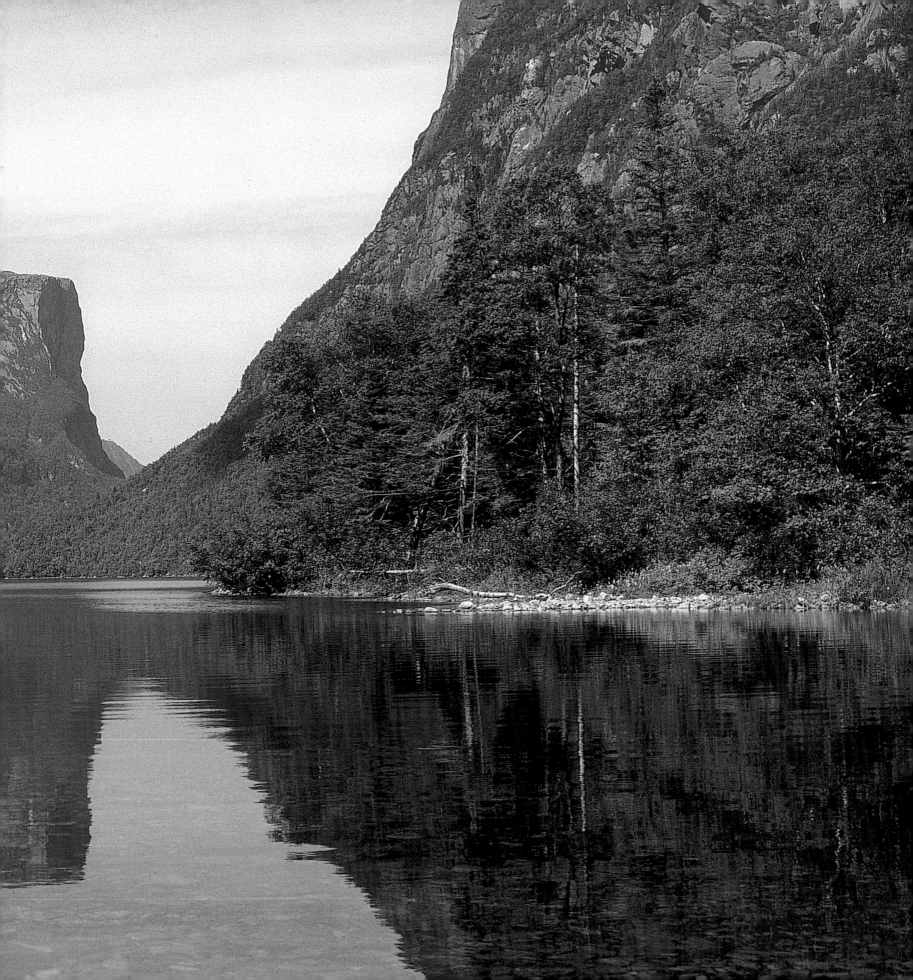

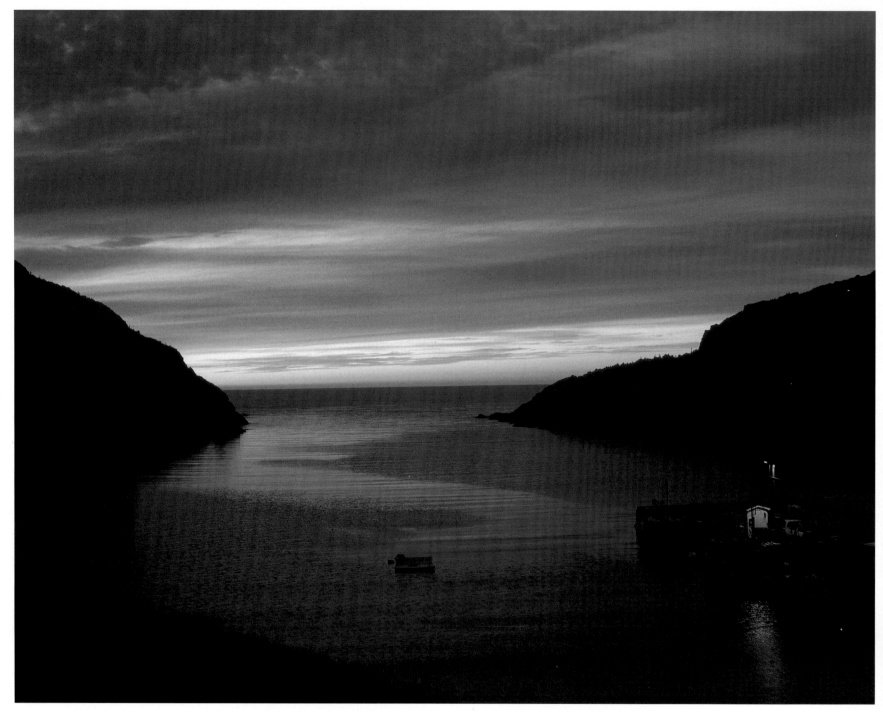

Bay of Islands, Newfoundland